ON FLY-FISHING
THE WIND RIVER RANGE

ON FLY-FISHING
THE WIND RIVER RANGE

ESSAYS AND WHAT NOT TO BRING

CHADD VANZANTEN

PHOTOGRAPHS BY KLAUS VANZANTEN AND BRIAN L. SCHIELE

THE
History
PRESS

Published by The History Press
Charleston, SC
www.historypress.com

Cover photos by Klaus VanZanten.

First published 2018

Manufactured in the United States

ISBN 9781467140430

Library of Congress Control Number: 2018948039

For Amanda.

CONTENTS

ACKNOWLEDGEMENTS

As always, all gratitude to my never-decreasingly remarkable children—Gretchen, Shreve, Ingrid and Klaus (their names are sequenced here with the aid of a random-number generator to perhaps but probably not mitigate the inter-sibling animosity that often arises from conjecture regarding favored-child status)—who as offspring are viewed with unvarnished envy by all those associates of mine who have children and, more importantly, whose love and lavish support are vital to every creative exertion I undertake but, puzzlingly, as of this writing, have not been forborne, despite the numerous shortcomings I have to this point exhibited as a human being and father.

Deeply heartfelt gratitude is extended to Amanda Luzzader, who with unflagging love, encouragement and a sort of irrational loyalty guided my steps back to the writerly pursuits I had resolved to abandon some years ago; whose suggestions and edits greatly improved the manuscript that follows (along with virtually everything I have written since making her acquaintance); and who, owing to her intellect, charm, extraordinary beauty and really stupefying obstinacy, has assumed the role of resplendent muse. Thanks next to Jason Reed, Brad Hanson, Russ Beck and Tim King, my fishing companions, from whom I have learned to fish and write and live; with whom I have laughed outrageously; and whose names are likewise ordered here by random lot to eliminate hints of partiality but who all know perfectly well the order in which they each are favored, or in any case grudgingly countenanced: Tim first, obviously; second Jason; next Brad; and lastly Russ.

Thanks to Tim Keller and the writing group (arranged alphabetically by nickname or first name): Amanda, Arielle, Britney, Casey, Emily, Felicia, Jeff, Jerome, Lora, Millie, Neil, Robyn, Sherrie Lynn, Turbo and Wally. Thanks to Pete Tyjas, fishing guide of the River Taw in Devon, whom I have not yet met in his actual person but vigorously intend to at some not-distant future point; he was first to accept a submission of my outdoor writing for publication, thereby strongly insinuating that it (the writing) would perhaps not be so pitilessly castigated if scrutinized by a general readership. Thanks to Harrison Mohn, the young fish researcher, for vetting the integrity of certain claims made by the author in the ensuing. Thanks to my mentors, who are in order of their appearance Jay Wamsley, Sandra Turner and Star Coulbrooke; together they have infected me with a refractory and at times execrable enthrallment for This Absurd Patois, which is to say the English language. Second to last of all and therefore significantly, acknowledgement and respect to Donicio Gomez and the owners, guides, part-time shop dudes, full-time scoundrels, mentors, fibbers and heroes of Roundrocks Fly Fishing, lately of Northern Utah.

Final and special thanks are extended to Artie Crisp of The History Press, whose personal, inside-the-same-room acquaintance I also have yet to make but whose unremitting patience and assistance is perhaps the most essential enabling element of the supervening work.

Please visit:
facebook.com/onflyfishing
facebook.com/roundrocks
tenkarabrad.wordpress.com
mtbbrian.blogspot.com
www.flyculturemag.com

NO CAUTION IN THEM

It's just before five o'clock in the morning. It's early August at Big Sandy Lake in the Wind River Range of Wyoming. For an hour, I've lain awake, impatiently waiting as the tent fly displays the first rays of day. In the half-light, I sit up and get dressed, head bumping the roof of the tent.

I unpackage myself from the tent like some great insect birthing from an egg sac, and then I sit in the frosted grass yawning, my breath smoking. Everyone else in camp is still asleep. The sun has not risen, but it lights the mountaintops on the west side of the valley.

Everything is new to me. It's all very interesting: every glade, every waterfall, the backcountry spruce and pines growing in copses that might have been arranged and groomed by some seasoned but sentimental gardener. Even the ground is a source of fascination to me, with its mosaic of miniature succulents, orange and purple lichen scales, jubilant forbs and the salt-and-pepper speckled pebbles that crunch when stepped on. And the Wind River peaks loom over all, inscrutable brooding gods whose moods shift as sun and clouds pass over.

Then there is the lake lying in the floor of the valley, its misty surface a mirror to reflect the shades of imperceptibly gathering light. And it is, of course, the schools in the lake that really bring me here. It's them I've come to see about. The mountains are astounding, without doubt, and the hillside thickets are darkly remarkable, too, but I have come here in search of water. I have come in search of trout.

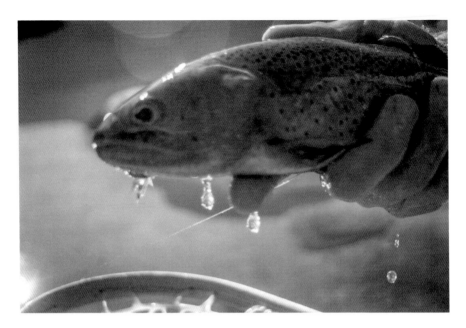

They strike whether the fly floats or sinks. They strike while it trails in the water as I wade. They hit so hard they miss the fly three times out of five. Still, I catch fish after fish. *Photo by Klaus VanZanten.*

My waders are stiff with cold. I push my feet down into the neoprene socks and pull them on as I stand up. My fly rod is already rigged and leaning against the branch of a bristlecone. I hastily eat a little breakfast and then leave the camp.

Not long after I reach the lake, a few fish begin to rise, and as the sun comes up, their feeding grows so frantic the lake dimples as though by hailstones. Such exhibits of widespread, single-minded animal behavior are always affecting, but this is more rising fish than I've ever seen.

I tie on a mosquito pattern in size 18, and the trout slam practically every cast. They strike whether the fly floats or sinks. They strike while it trails in the water as I wade. They hit so hard they miss three times out of five. Still I catch fish after fish. Soon the fly is sodden and slimy, beginning to unravel, and after I unhook the eleventh or twelfth fish, it's just a few wraps of thread on an otherwise bare hook.

My first trip to the Wind Rivers has begun.

It's late morning in July and already hot and swampy on a Wind River trail on the eastern side of the Continental Divide. I'm backpacking with six other people whom I don't know very well. I was invited by a guy I met while working at a fly shop. The hike is ten miles give or take, and our party splits into fast hikers and slower ones. No longer a rookie, I'm the slowest member of the fast group. Five stream crossings lie across our route, requiring us to shuck our hiking boots and step with care as the streambed cobbles shift and cluck beneath our feet. The fast group fords the first crossing, and then we get our boots on and watch for the others. I make a weak attempt at conversation, which results in an awkward fizzle, so we sit in the grass and swat at the jittery clouds of mosquitos as we wait. The slow group does not appear, so I get out my fly rod, tie on a size 14 Elk Hair Caddis and cast to the stream. The fly alights on the upwelling water at the foot of a fall. A small cutthroat eats the fly with a carelessness that borders on contempt. I bring him in quick and unhitch him, and he swims off. I cast again to the same place, and the same exact thing happens. After that, I fish at each crossing, even if the wait is short. At the third crossing, I see the slow group before I even get my rod set up, but I cast anyway and catch a fish. Over the course of the hike, I make eighteen or twenty casts and catch the same number of fish.

It's nearing lunchtime the final full day of a longer trip. We've been fishing in the rain at a stream near our camp. Our jacket hoods are up and hats pulled low, but then the sun comes out, so I lie in the grass by the bank to eat my lunch. Propped on one elbow, I peek sleepily between the reeds and see fish feeding in the creek. They contend for position and take turns gulping the mayflies that glide down the drift like tiny sailing ships.

Dave's son, Braden, joins me and watches the fish awhile. He's maybe thirteen, a quiet kid. My fly rod is leaning on a rock behind me. Braden asks if he can try it.

"You fly-fish?" I ask.

"I have a few times. I'm not very good yet."

"Yeah, it's tricky. Well, sure, grab that rod. Give it a try." He picks up the rod and unhooks the fly from the keeper. Then he goes to the grassy bank and waggles the rod back and forth over his shoulder. The line flounces in the air, doubling back and whip-cracking.

"Lower your elbow," I say, without getting up. "Keep your wrist stiff." He doesn't understand, but I don't want to get off my ass to demonstrate. Eventually, he slings the line in the vicinity of the stream like a burst of Silly String. It lands in a heap on the water practically at his feet and then floats down the current, dragging and sagging.

And despite his best efforts, Braden catches a fish. It crashes up into the fly and pinwheels glittering over the water before splashing down again.

"I got one," says Braden over his shoulder. It's unclear if he's pleased about this or not.

"Yeah," I say. "Good job."

I assume Braden'll set the hook at some point that day, but there's ten feet of slack line on the water between the fly and the top guide, so it's probably not going to matter.

"Gotta set that hook," I tell him through a mouthful of trail mix.

"Gotta do what now?"

"Pull back. On the rod. Lift the rod tip."

It's too late—the fish shakes the hook, but another one takes its place right away. I don't know if Braden even notices. But the replacement fish is kind enough to set the hook itself, and then it begins a sort of one-sided struggle, like a dancer who commandeers the lead from a partner who doesn't know the steps.

"You always have to set the hook in the fish's mouth," I explain. I pantomime a hook sticking me in the cheek. "Otherwise, he'll just spit it out."

The line has drifted downstream and straightened in the current. The replacement fish jumps and tail-walks, which strikes me as show-offy, but it's nice of him to stay hooked. I can't think of another place where a kid who knows so little about fly-fishing can catch two fish on his first cast. If it worked this way back in the real world, every single person on Earth would own a fly rod and waders.

Braden lifts the rod tip. Finally. It flexes with the weight of the fish and current. He reels in and meets the fish at the bank. It's a thirteen-inch rainbow, respectable for that stream. He unhooks the fish and lets it go. Then he rests my rod on the rock and walks away, apparently under the impression that while fly-fishing may be an easy way to catch trout, it's too complicated to be very much fun.

It's MIDDAY, MID-AUGUST, MID-STREAM. It's warm, with only a few clouds moving through, and I've skipped lunch with the others to fish by myself. Fly choice isn't important today. The fish are taking dries over fast water, so I launch a big Stimulator and the fly sinks in the jostle. But I see the bright-yellow hackle below the surface, and there comes the flicker of a striking fish. I set the hook and strip in a two-pound cuttbow. I lead him into my net, but I don't lift him from the water. The fly falls out of his lip, and he swims against the side of the net. He's got a battered, oversized tail fin—probably a favorite of the local spawning females. With his bright, silvery flanks and fuchsia throat, he glints in the sun like a jeweled sword. For a moment, I debate whether to get a photo of him. In a few minutes, I'll really wish I had, but he's not even the nicest fish I've caught that day, let alone that trip, so I push the net down and out from under the fish. He swims free. Then I wring the water from the Stimulator by pinching it in a fold of my shirtsleeve, but the Stimmie just won't float anymore. So I bite the fly off the tippet and stick it in my hat to dry. Then I open my flybox, but instead of grabbing a new Stimulator, I wonder if there's something in there that these fish will not eat. I poke around and come up with a Killer Caddis, which is just five iridescent beads and a little crystal flash on a size 8 nymph hook. No detail, no anatomy. My buddy Chip gave it to me while we were fishing for bluegill on Pelican Lake in the Uintah Basin. I shrug and tie it on. Nothing on the first cast. Nothing on the second. I frown a little. Okay, I concede, the Killer Caddis hasn't got much of a following up here. Noted. But on the third cast I feel a tug, and a minute or two later, I net a fish. I reach down to jiggle out the hook, but before I let the current flush him from the net, I do a double-take—it's the big-tailed cuttbow I just let go, the fish that bit the Stimmie.

It's AROUND 2:30 IN the afternoon. Jason and I are halfway through a five-day trip on the Indian Reservation, where you buy a "Trespass Permit" instead of a Wyoming fishing license. We're heading to a cirque and deep lake where I fished the previous year. Jason has seen the photos of the fish I caught there, so even though I'm leading the way, I have to hurry to stay out front. Our fly rods flex and bob eagerly as we go.

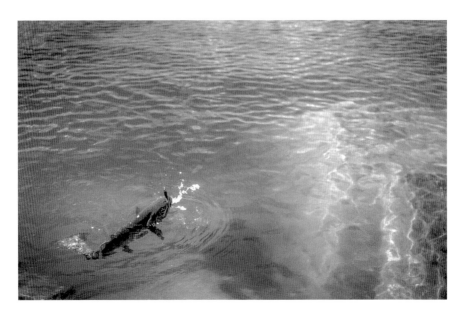

To lose a fish like this to a bad technique or other misstep would call for an unsightly blotch on my record. *Photo by Klaus VanZanten.*

We pass by two other lakes on our left and see fish hunting in the shallows like German U-boats. They zigzag over the light-colored mud among the submerged rocks.

"Look," I say to Jason, pointing with my fly rod. "Look at that big boy." It's a large cutthroat. From thirty yards, I can plainly see his crimson gill plate and anvil-shaped head. He's edging in toward the bank.

"Kinda far out there," says Jason.

"Coming this way, though." I'm equipped with my tenkara rod, perfect for stealth-casting over shrubs to hook fish near the shore or beneath overhanging banks, but its reach is only thirty feet. In my brain a frantic calculus gets underway, estimating the cutthroat's rate of travel and approach angle to determine where on the bank I'll need to be when he comes close enough for me to reach him.

I'm heading west on a game trail, about ten feet inland, with the lake on my left. The cutthroat is also westering, with me on his right. As we converge, the chance of him spotting me goes up and up.

"He's gonna see you, dude," says Jason. He stops on the trail behind me to stay out of sight.

"Maybe if I slow down he'll pull ahead of me." I motion the play with my hands.

"Maybe. I dunno. He's getting away."

"Shit. He's really, like, big."

"Yeah, he's big."

"I know."

That the cutthroat is big makes the situation quite a bit worse than if he were small. I cannot—must not—lose this fish. To lose a fish like this to a bad technique or other misstep would call for an unsightly blotch on my record. I go into a crouch and blunder through the chest-high shrubs, tripping and scrambling to stay with the cutthroat and line up a shot from behind him.

I lose sight of the fish. "Where's he at?"

"Still there. By the rock. On the left."

"That one?"

"Your other left. Don't let him get away. See him?"

"Yeah. Shit. Shit."

"He's getting away, dude."

As the cutthroat nears the bank, I bark my shin and stumble over the stout knuckle of an alder trunk, maintaining just enough footing to press ahead with a kind of clawing, swimming motion. Jason stops kibitzing and watches bemused as I thrash for open ground so I can start casting.

On my tippet is a size 10 Fat Albert to imitate the grasshoppers that crackle through the air here like sparks of unharnessed electricity. They emerge on warm afternoons, advertising for sex by arcing up from the grass to snap and flash their red and yellow wings, a corps of miniscule semaphore signalmen.

The Fat Albert is a lumpy and crude imitation, more suggestive of a stepped-on Tootsie Roll than a sleek alpine ornithopter, but it is also a durable artificial, constructed mainly of foam, and remains buoyant even after multiple maulings in the toothy mouths of mature trout.

The cutthroat still doesn't see me. God alone knows why. This fish must be really distracted—family problems, pressure at work. It's slightly unnerving because once he catches on, he'll vanish like he never even existed. For now, he's within fifteen feet of the bank, and I'm shadowing him. But he's still pulling forward, and I need to gain another twelve feet on him if I want to cast far enough ahead of his nose for a clean, conspicuous take. I begin false-casting furiously, groping for the zone between getting spotted and getting into range. I move in.

And he turns around. Something tiny on the water has caught the cutthroat's eye, and he turns slowly for a better look. It's a midge or spinner, invisible to me. The cutthroat takes it. He doesn't swirl or jump for it, but

I clearly hear a wet *ploop* as his beak breaks the surface and then closes for the eat.

Now the cutthroat is heading straight at me. I freeze, my limbs motionless in awkward attitudes. He swims past and I keep still, not even blinking, a land-lubber in a game of freeze-tag with a water ghost. He's tall through the body, slight kype to his underbite, dark bronze back. Confident, predatory. He eats again from the surface, *ploop*, and then angles off away from the shore in the direction he first came from.

All at once I'm behind him again, but I've got only one chance to cast before he's out of reach. A flurry of possibly relevant considerations occurs to me—wind direction, what's in my backcast, if the yogurt in my fridge back home has maybe expired. I make one false cast and then lay the fly down.

And it falls short. Fat Albert comes down slightly behind the cutthroat, but he comes down hard. Comes down like a cannonball. There's a splash, radiating rings. The fish detects the commotion, circles back and opens his mouth to take the fly. Good ole Fat Albert.

I pull back on the rod. My timing is perfect and will result in a very secure hook-set, probably in the cutthroat's upper lip, where it's bony and tough. I'm already picturing how to play him. The hook catches, and the line traces up out of the water. The rod bends.

And then the fly comes free. There is a procession of poorly conjugated profanity. From me, evidently. It's mostly just the word *shit* repeated over and over. I stuck the fish. The hook stuck him. It's over. My eyes follow the fly and line sailing up from the water, and I know that when I look down again, I'll see only a whorl of mud and an eddy in the shallows where the cutthroat had been.

I make a sloppy backcast. Too low—it whipcracks and nearly snags the branches at my back, but when I look down, the cutthroat is still there. I gawk. Too big to have been bothered by the inconsequential prick of the hook, the cutthroat has come about again and is wondering where his meal went. He's not spooked. He's just annoyed.

My cast shoots forward, and I somehow place the fly right back down on the disturbed water. It must seem to the fish as though Fat Albert never left the scene. The cutthroat opens wide. His pointed snout breaks the water, looms over the fly.

And I rip it away from him. A sudden case of buck fever. Fat Albert rockets back through the water, and then the line and fly are airborne again. I catch a glimpse of a turning tail, fins flattened to body as the

cutthroat flees. But when Fat Albert loops forward for his final cannonball, the cutthroat 180s around.

He's four feet from the fly, and now he's pissed. He pumps his tail for speed and hits Fat Albert like a train. When his jaws clamp on the fly, he turns on it fiercely, raising a semi-circular sheet of water with his tailfin. It's a beautiful take—a wild, violent take by a big, aggressive fish. When I play it back in my memory, it unfolds in slow motion, the fish bright, mouthparts radiant white, every water droplet a shard of sunlight.

I lift the rod. Upper jaw for sure. The line zings taut like a telegraph wire. It's like setting the hook on a two-by-four. The cutthroat is hooked. He bolts.

And the rod shatters. There is a drastic, glassy *crack*, and the tackle falls slack. I falter back, and the line drifts down, rod tipping forward like a beaver-felled sapling into the water. A lower section of the rod has shivered into scores of impotent strips of graphite composite. It looks like Elmer Fudd's shotgun after Bugs Bunny stuck his finger in it. There's no cartoon soot on my face, but I'm as stunned as Fudd, eyes blinking.

When I regain my senses, I hear laughter. Jason comes up from behind, laughing his booming baritone laugh.

It's the end of my first full day in the Wind Rivers. Big Sandy Valley blazes redly in the fiery sundown. The evening planets and stars burn through the dusk, and all at once the place is a cosmic island of granite, floating, disconnected from the world. Down at the lake, the fish start to rise again just as my camp mates begin breaking sticks of firewood against their knees. I head out to fish down by the outlet, where the water is deeper. Hoping to conjure up a big one, I hop out onto a rock and cast long. Sometimes I hook a trout and sometimes the trout gets away, but they hit and hit. They are mindless, elemental, and there is no caution in them. Neither is there desire or sorrow. The fish want only one thing: to live. And so they feed and breed. Nothing else. They don't speak, sleep or dream. Each time I catch one, I'm reminded of how unlike them I am, how complicated and absorbed I am by the absurd abstractions of humankind—time, ownership, failure, belief. But with each fish I let go, I grow more aware that I am at least, in my cloddish way, among them.

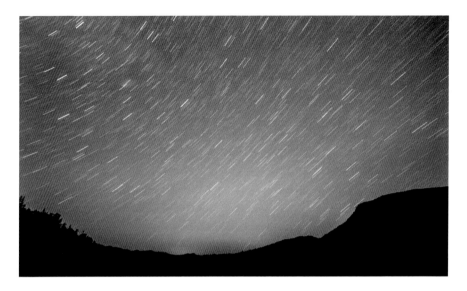

With each fish I let go, I grow more aware there is nothing but a thin skin of vapor between this lake and the rest of the universe. *Photo by Klaus VanZanten.*

There are no cell towers or power lines above us, no pavement or sewer pipes below. All that lies between us and the center of Earth is twenty miles of bedrock and a sea of ageless molten iron, and there is nothing but a thin skin of vapor between this lake and the rest of the universe.

THE FLIES I LEFT BEHIND

The first time I got invited to backpack the Wind Rivers, I'd never been to the backcountry. I'd spent some time in the army, so I knew how to wear a rucksack, but I hated it. Since then, I'd left the military, gotten married, had a few kids and become a desk jockey. I no longer had a backpack or tent or even a good pair of hiking boots. I'd get a little bit winded just crossing the parking lot of some of these bigger retail stores.

To summarize, I was in terrible physical shape, had no recent experience and didn't own a single article of backcountry gear when my friend Shawn invited me to go backpacking for the first time. Naturally, I accepted. Shawn was a natural salesman. He was quick to smile, and he made everything seem easy. I kept expecting him to extol the fantastic views or solitude or downplay the strenuousness of the hike in favor of the prospect of visiting one of the ten largest glaciers remaining in the contiguous United States. But Shawn was smarter than that. He just showed me his fishing photos and let the gleaming, wild trout do the talking.

"Oh, wow," I said. "Oh, wow."

These were big trout. Shot after shot of three-pound trout and a few bigger. I bit my lip to keep the lid on my exuberance, which kept rising like a song from my heart. I'd been fly-fishing for less than five years at the time and hadn't had much experience chasing big fish in the wild.

"So," I said, "we'd, uhm, we'd be catching a lot of these? This size?"

"Yeah," he replied with a shrug. "Every day. As many as you want, basically."

I turned to face him. "I'm not asking for guarantees, but just be completely real for a couple seconds. You're saying it's always like this? No exaggeration? These fish? As many as you want?"

"No exaggeration. Many as you want."

What else could I do? What happened over the next two summers reshaped the way I view the entire pursuit of fly-fishing. All of it—the flies, the fish, the water and myself as an angler. It changed the way I looked at other things too.

Good gear was essential if I intended to make the trip and not perish in the attempt. I was taking my thirteen-year-old son, Klaus, with me, so we'd both need proper footgear, shelter and lots of other equipment. I'd need to seek advice, make a budget and read product reviews. I'd need to get myself into some kind of decent physical condition, too, if that was even possible in the time remaining. I had only a few months to do all of this, so I immediately ran down to the fly shop to look at the flies.

As a fly angler, I'm largely self-taught, and while I was never a great teacher, as a student I was a lazy little shit. Everything I knew, which wasn't much, had been gleaned by joining conversations with experienced anglers and pretending to know what they were talking about. You can pick up a lot that way—just keep your mouth shut and nod.

But when I got to the shop, I saw Clarence stocking the shelves, and I paused at the door. He looked up from a box of tippet spools and flyline. "Help you find anything?"

Another reason I liked Clarence is he lacked the intimidating presence of a more typical outdoorsman. He wasn't tall or chiseled—sort of the opposite, really. He was on the stocky side and wore thick eyeglasses. If you tried to guess his hobby, you might say video games before fly-fishing. I liked the guy, but I'd gotten the impression that he was one of those Jedi fly anglers and that his bullshit detectors were pretty sensitive, so I tried to play it straight.

"Hey, Clarence." I always called him by name, like we were old fishing pals, hoping he'd someday do likewise. "I need to know what flies to take on a backpacking trip."

"Where you going?"

"Wind Rivers."

"The Winds?" He turned back to his work. "Just take anything," he said, waving at the dry flies. "You'll catch a bazillion fish." It was good to know that savvy guys like Clarence called it "the Winds," but it seemed like that was the beginning and end of his briefing. I knew that Clarence was a bit aloof, but I'd always assumed that was because there was only so much an

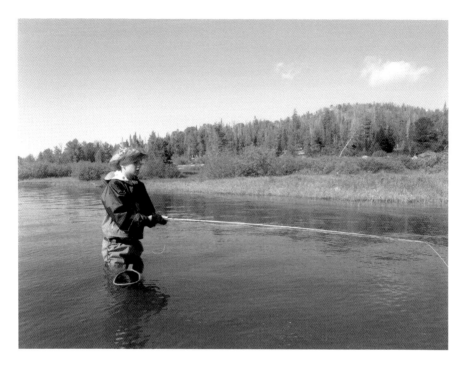

For Klaus, it was Fly Angling 101, with five days of personal instruction from the very best tutor in existence: lots of real fish. *Photo by Chadd VanZanten.*

angler like him could do for one like me. It was too much to hope that he'd drop everything and hand-pick a selection of flies for me, including some talismanic pattern with an arcane name like the "Higgin's Double Highwayman" or the "Rusty Badgerflank Sedge."

"Just anything?" I asked, turning to the fly bins.

"Yeah, whatever. It's crazy there. When are you going?"

"August."

"Oh yeah. You'll have a blast." He was right. I stuffed half my flybox with anything, the other half with whatever, went to the Winds and caught almost exactly one bazillion fish.

Shawn had not exaggerated. I'm not sure he could have if he'd wanted to. In the lakes, the fish religiously observed morning and evening rises and then swam along the edges until dark. In the rivers, they were shamefully surface-oriented and always ready for a meal. And they were flexible too— open-minded. If they were eating mayflies, they'd gulp a big Yellow Sally just to keep things fair. I figured truer imitations would probably catch bigger fish, but for the first few days, I hooked so many it didn't matter. For Klaus

it was Fly Angling 101, with five days of personal instruction from the very best tutor in existence: lots of real fish.

I was still a beginner too, so I learned almost as much as Klaus did on that first trip, and as the novelty of the place wore off, my approach matured. Instead of casting frantically to the shoals of fish I knew I could hook, I matched what I saw on the water and fished where I thought the choosier lunkers might be, and the Winds rewarded me with bigger fish only slightly less numerous than their smaller, more reckless brethren.

Still, as that first trip came to a close, I got a feeling that Klaus and I had taken unfair advantage of the place. All at once, I saw the Winds the way other fly anglers do, as a mythic center of worship or study—like the Kaaba or the Library of Alexandria. I'd been too busy to see it at first, rushing from bank to bank and fish to fish, but it was almost as though the rivers and lakes and fish wanted us to put forth more effort but were too polite to insist. Like when Klaus called for help one day from forty yards upstream.

"Dad, I lost my caddis and I'm all out."

"What happened?"

"I dunno. Must have tied the knot wrong." Klaus lost a lot of flies up there—gnawed them apart with hemostats, popped them off with sloppy casting. I should have slowed down to show him better practices, but with so many fish to catch it was hard to think big picture. There were always a few more shop-tied Prince Nymphs or PMDs in my box. It was too easy to hand Klaus a fuzzy handful of whatever and send him on his way.

When we got home, Shawn immediately invited us to the next trip, which was set for the following August. I didn't have to think about my answer. In my head, I was still there in the Winds, remembering the trails, the water, the fish. However, I promised myself I would approach the next trip differently. I would try to be the scholar and pilgrim I was supposed to be.

I started with flies—I wouldn't fish with just anything. I'd learn to tie better, tie all my own flies and use them wisely. Sheridan Anderson, author of *The Curtis Creek Manifesto*, recommends four flies per person, per day of backcountry fishing. And that's a great rule for myth-shrouded Curtis Creek, where fish can be as skeptical as grad students, but I was tying for the Winds, where fish often rose two or more at a time to a well-presented dry. The problem wasn't finding fish to catch—it was bringing enough flies to catch them all. Standing on the boulder-strewn bank of a lake, watching these unbashful trout wander past without a fly to cast, would be the purest sort of agony. I figured I'd need five per day to cover me for our next

stay. Klaus would probably need six, and a strategic reserve of common patterns was probably in order too.

As a tier of flies, I'd been working hard on advancing to the rank of "talentless hack," and I'd been told I still had a ways to go. I'd tried teaching myself by looking at books, but that was a lot like trying to learn how to knit by looking at sweaters. So, I got myself a tying instructor. This turned out to be maybe the best decision I'd made since taking up fly-fishing in the first place.

His name was Tim King, a tall, burly, amateur hockey player with a perpetual grin that beamed through a beard of steel wool. Tim was as skilled at storytelling as he was at fly-tying, and he taught me as much about the former as the latter. In fact, he couldn't properly teach a fly pattern without telling a story about how he'd learned to tie the fly—or the origin story of the pattern or the story of how he'd procured the obscure and exotic tying materials he was using to tie it.

He'd distribute a wispy pinch of some prized rare material to all of us students, and in his gravelly baritone, he'd say, "Here. Use this. It's blue-eared pheasant hackle I mail-ordered from a guy up north back in '82 or '83. It doesn't come cheap, but we might as well tie this one right."

As we mounted hooks in our vises and fumbled with our bobbins, Tim would scratch his beard and muse about the Mail Order Guy from Up North. "This guy had a great catalogue—let's start by tying in the tail, down at the bend—and he was a great tier, too. I think he was a retired gynecologist, so I guess he was good with his hands."

We students would listen as we broke off thread and clumped up our dubbing.

"Then I found out he wasn't doing mail order anymore," Tim might say. "He retired from his retirement—careful, you don't want to crowd the head—so, I decided to drive up there. I needed the hackle to finish off an order. Plus I was all out of seal fur. You know how that is. Okay, tie that off with a half-hitch before we go to the next step."

The story might evolve to include a hitchhiker or a busted camshaft or a fistfight—or all of these. Between plot points, there would be tips on preventing your material from rolling over the hook or how to whip-finish without a tool. Soon Tim would reach the denouement, in which he and his hitchhiker would meet up with the Re-Retired Gynecologist Mail Order Guy from Up North, and together they would unearth not only the needed hackle and seal fur but also something even more precious, like the breast feathers of an African bee-eater or a sack of polar bear dubbing.

"I asked him how much he wanted for it, but he wouldn't take my money. Said he wouldn't take a dime from me. So, we all went into town and I bought him a beer." Somehow, when Tim finished the story, we'd each have tied a satisfactory example of the fly. The lesson would end, and the next story would begin.

But despite the advanced level of Tim's raconteurism, it'd take time to fill up my Wind Rivers flybox and Klaus's too. The trip was set for early August, so I started tying in March, and even so I felt vaguely behind schedule all spring and summer. I stuck with basic standards: parachute patterns, caddisflies, simple upwing dries and common nymphs. These were effective, easy to tie and durable. I further ruggedized them with the techniques Tim had interspersed in his stories, like reversed-wrapped wire on bodies or tying off after each step with half-hitches and head cement.

One pattern that I knew would join me on the second trip was the Purple Haze, which was new and sexy back then. It was created by Andy Carlson, a guide on the Bitterroot River in Montana. It's just a Parachute Adams with a purple body, but I knew this variation to have hypnotic effects on the cutthroat trout of the Blacksmith Fork, which is one of the places where I learned to fly-fish and a former stomping ground of the aforementioned Mr. Anderson. The Purple Haze was one of the first self-tied flies I'd had any real success with, and I could not have been more eager to take a couple dozen of them into the Winds.

After one particularly productive tying session, Klaus spotted the growing stockpile arrayed in my production flybox.

"When can we split them up?" he asked.

There was no good reason to put it off, but I said, "When we get there." I think I just liked the way they looked all together in one flybox.

I ended up tying about fifty flies for each of us. On the first trip, I may have packed twice that many. I'm not really sure—they were all shop-tied flies with no special distinction. My home-tied flies were tougher and smarter, so I needed fewer, but it still took me all spring and summer. I sometimes tied one or two evenings a week, which often superseded family, friends and fishing. Even packing for the trip had to wait; I tied almost every night the week before we left.

The outcome was row upon row of flies, beautifully graduated in style and size. Hare's Ear Nymph, Purple Haze, Manflower—all were assembled. And they weren't lumpy or head-crowded—if the fly didn't look damn-near perfect to me, and sometimes no more than half I tied did, they got left

behind. I'd tied a phalanx of Elk Hair Caddis so handsome and uniform in quality that it gave me actual chills.

This, I thought, was the effort the Wind Rivers expected. Instead of a decadent fish grab, I would matriculate into backcountry angling. With this flybox I would make my angler's pilgrimage—my offering.

On the morning of my second trip to the Winds, our company of ten met at dawn. The drive began on the U.S. Interstate Highway system, but once we reached the Wyoming borderlands and saw the Wind River peaks towering over the open range, we juddered down the state highways and the unpaved washboard roads of Sublette County.

Shawn and most of the others rode in our buddy Nate's big Suburban. Klaus and my neighbor Tony came with me in my pickup, along with the party's backpacks, which were piled in the bed. Tony didn't fish, but this was his first trip to the Winds, so we compared our pack weights and preparation efforts.

"There was so much to do," Tony said, massaging his temples. "I wasn't done packing until last night. Hope I didn't forget anything."

"Oh, I know," I chuckled. "I've been up late every night this week tying flies."

"How many flies do you need for a trip like this?"

That's when I realized I had left my flybox and flies at home. All one-hundred-some of those meticulously tied flies were at home in my bedroom. I was on cruise control at sixty miles per hour to fish the Wind River Range of Wyoming without a single fly in my possession. I stifled a mouthful of expletives and nearly swerved off the road.

What were my options? Turning back would mean splitting up the party, not to mention putting Tony, Klaus and myself three hours behind schedule, which meant hiking in after dark, which was unacceptable, even dangerous. Besides, all the backpacks were in my truck. They'd never fit in Nate's Suburban—they had seven people in there already.

What were my options? There were no options. Inside that flybox was my Wind Rivers dissertation, but I couldn't go back for it.

Tony sat waiting for an answer to the earlier question. "Something wrong?" he asked.

"I just realized I left those flies at home. In my room. On my dresser." I repeated this in my mind—with the expletives. It was a lot longer that way.

"That doesn't sound good," said Tony.

"No."

"Did you bring any others?"

"No."

"Hm. What're you going to do?"

I tried to laugh it off, but Tony could tell this was a big deal, so we drove in silence for a few miles. I glanced at Klaus in the rearview mirror. He'd been dozing; he was wide awake now. "You brought a flybox, right?" I asked him. Klaus nodded, but we both knew that wouldn't save us. He got his flies from me, and because I was still learning, he usually had only twenty or so flies at any given time, none of them anything to be proud of.

"What's in it?" I asked.

"A few mayflies. One Purple Haze. Some caddises, maybe. Why didn't we split up the flies before?"

"We'll pick up some more at Midway."

Just outside the desert village of Big Piney, there is a sprawling compound of gas pumps and low-slung rustic buildings called Midway Mall. Part truck stop, part Old West museum, it was our final pit stop on the way to the trailhead. The boardwalk outside was decked out with thousands of sun-bleached antlers. Inside, all manner of wares were for sale, from snack food to horse tack to naked lady mud flaps. Taxidermy and antique rifles hung on every wall—foxes, jackalopes, old Winchesters, even a mountain lion.

We had stopped at Midway on the first trip too. I'd glanced at the fishing gear assortment, but only on my way to the nacho cheese pump, because I'd bought all my flies from Clarence that year. I vaguely remembered Midway's selection as slim and perhaps even shoddy, and so as we pulled up to the place again, I hoped that maybe they'd restocked since then or that my first impressions had been somehow mistaken.

Unfortunately, I was right. The flies were sparsely dressed, garish, lopsided. They felt brittle; some were crumbling in the display case. There were no Purple Hazes. Even so, they cost double what Clarence charged me. I had little interest in dropping a hundred bucks on

Part truck stop, part Old West museum, Midway Mall was our final pit stop on the way to the trailhead. *Photo by Chadd VanZanten.*

substandard flies, but I couldn't have replaced all my flies for any price—there just weren't enough to choose from.

Under the glassy gaze of dusty bobcats and bison, I pored over the display case, scrutinizing not only the patterns but also each individual fly. A slow Buck Owens tune played on the sound system. After twenty minutes, I'd chosen my flies and a two-dollar flybox to carry them.

Shawn and the others chomped jerky out by the Suburban as I waited in the checkout line behind an old trucker in a foam-crown ball cap. Through his mirrored shades he looked at me in my fresh hiking pants and brand-new boonie hat. I nodded diffidently. He looked away.

When I stepped up to the register and told the cashier how many flies I had, she acted like she misheard me. "Twenty-one?" she asked, eyebrows raised. I guess even she knew the flies were crap.

"Yeah," I sighed. She pursed her lips and shrugged as if to say, "Hey, it's your money, pal." The total was somewhere north of fifty bucks.

Back in the truck, as we pulled onto the highway, I said to Klaus, "We'll have to be careful with flies this time." He nodded. Then he shook his head.

We continued through the unfenced expanses of sage and rabbitbrush. The small herds of pronghorn we passed by regarded us warily at first and then bounded away abruptly as if by hidden signal. Soon the road climbed into the hills, where groves of aspen and fragrant spruce appeared. Weathered boulders sat like Olmec heads with their faces turned skyward. We came to the trailhead.

Even though the hike took four hours, I don't remember much about it. We stopped at the sunny parkland overlooks while cumulus clouds scudded enormously overhead. We stopped at the picturesque bends in the trailside stream. I probably should have looked longer or at least shot more photos, but mostly I fretted about the fly situation.

Thirty-two flies. After pitching our tents, Klaus and I took inventory of our flyboxes, and we counted thirty-two flies between us. There were no other fly anglers in the group, only spin-anglers, so we couldn't borrow or trade. Thirty-two flies of disparate source and pattern would have to withstand one bazillion Wind River trout.

Instead of the rows of caddisflies I'd tied, we now had nine Elk Hair Caddis—seven I'd bought at Midway and the two home-tied flies Klaus had in his box. In the Winds, a caddis will usually catch something, so these would form our shaky front line. We each claimed one of the home-tied flies. Klaus chose the size 12 with tan body and silver wire rib, leaving me with the size 14 with green body and copper wire. Both were products of my

early, clumsy attempts at fly-tying, but they still put the coarse Midway flies to shame. We pinned them into our boxes, handling them like miniature, sacred artifacts.

Eight mayflies of varied flavors would serve as our irregular troops. A few BWOs, a Cahill Parachute, nameless mosquito patterns. Like their natural counterparts, they wouldn't last long. Most of Klaus's had been fished already and weren't in great shape; those from Midway looked like they might not even float. We divided them between us.

Klaus had a single size 12 Purple Haze in his box, one of the first I ever tied. It wasn't a perfect example of the species, but it was the home-tied pattern I really wanted to try in the Winds. I knew Klaus would probably lose or exhaust the fly long before I got a chance to cast it, but I resisted the urge to confiscate it.

"Know what?" I said. "You keep that one."

Without so much as a shrug of protest, he replied, "Okay."

A motley of terrestrials, nymphs and streamers rounded out a regiment I calculated might hold up for three days. After supper, there was time to fish the evening rise at the nearby lakes, but I headed for bed. I seldom sleep well while camping; that night, I tossed in my mummy bag with extra restlessness, mourning my forgotten flies with their glossy hackles and fresh, prickly dubbing.

Next day, Klaus and I woke early to fish the morning rise. As I walked with my son in the stillness, I forgot about the fly shortage. Once there, we found the brook trout jumping to a midge hatch. This primeval, mist-veiled sight alone certainly counted for something, but it suddenly galled me to consider the trout I'd have caught with the home-tied Griffith's Gnats I could not fish.

Klaus and I tied on our smallest mayflies—laughable midge imitations. Klaus used a worn-out PMD and cast into the chaos for a quarter hour without hooking up. I chose a clunky Midway mayfly, but the too-skimpy hackle wouldn't float the too-heavy hook. I fished it in the surface film and got one half-hearted hit, but the fish weren't hitting just anything that morning.

I switched to a Woolly Bugger. I had two, both from Midway—one black and the other snot green. Both were tied on medieval-looking hooks with comically oversized barbs that I never could smash all the way down. I'd also picked up a Mickey Finn from Midway, and Klaus had a bugger he'd brought from home. This constituted our supply of streamers.

I gave the green bugger a decent showing despite my melancholy. On its first cast, I felt a bump. After the second, I was fast to a nice brookie that had been lurking deep down and far out into the lake.

Photo by Klaus VanZanten.

"Switch to your bugger," I shouted to Klaus. "Just don't lose it." He tied on his olive bugger and caught a brookie of his own.

As the morning went on, we met with success more typical of the Wind Rivers. Still, I cast carefully and checked my knots after every strike. When we got back to camp, it wasn't the fish we talked about.

"Still got your bugger?" I asked.

"Yeah. What were you using?"

"This green one. Kind of ugly, but it did the job. It's nice and heavy."

I gave Klaus the black bugger so we'd both have two streamers. We'd repeat this process of swapping and reassigning our flies several times, figuring that an equal distribution gave us better chances of success. But Klaus held on to the Purple Haze.

For the rest of that day, we fished our flies the way our fighting boys expended ammo during the Battle of the Bulge: we chose our targets shrewdly and aimed carefully. This resulted in some unforgettable fish. On Black Joe Creek, Klaus's careful and exceptional casting from the bankside reeds yielded him a well-struck and hard-fighting sixteen-inch cuttie. I recall each of the cutthroats that came to my single home-tied Elk Hair Caddis that day—I unhooked five from the fly before it began to disintegrate, and I caught one more with it after that.

We developed ways to conserve flies. Instead of our usual practice of fishing thirty or forty yards apart, Klaus watched me until I caught a fish, then I watched him land a few. It was a little like shooting pool. And rather than fishing relentlessly all day long, as we had during the first trip, we took frequent breaks, recounting our fish and trading flies the way school kids trade baseball cards.

"You sure I can have this one? How many fish did you catch on it?"

"I dunno. Five or six. Go ahead. Take it."

At the end of the day, we'd used up only five flies total—a bit more than half of what Mr. Anderson predicted for two people.

On the third day, Shawn said he'd lead the party up to the lake said to hold the big cutties, three pounds and up. The hike would take less than two hours, leaving most of the day for fishing. Big lake fish and high numbers would surely cost Klaus and me more than five flies, and even the conservative estimate of four flies each might decimate our reserves. If the fishing really heated up, which was likely, we'd face an unfortunate decision: prematurely stow our fly rods or blow the fly budget.

I suggested to Klaus that we take an alternate route. Instead of taking the trail with the others, we could hike upstream along the tiny creek that drained from the cirque. It would show us some unseen country, and we'd save on flies by taking longer to get to the lake.

We talked and laughed as we clambered up alongside the creek, which dwindled to step-over trickles in some places and widened to sylvan pools in others. In one place, we hopped from one bus-sized boulder to the next, following the creek by listening for its ghostly splashing somewhere far below.

The fish in the creek were small, never longer than twelve inches, but they went easy on our flies. We tried to return the favor. Sometimes we gave slack and let them shake our hooks rather than landing them. By late morning, we'd both hooked high double digits and lost only a few flies. The one notable casualty was my fault—I popped off the snot-colored Woolly Bugger with a bad cast. We searched among the boulders in my backcast for twenty minutes but never found it.

At noon, the wind kicked up storm clouds. As we approached the lake, the air went calm and the sun beamed out. The craggy wall of the cirque shone so clearly on the lake's flat mirrored face that there was scarcely a detail of the actual landscape that we could not see in the reflection. The pale granite flanks of the mountains formed blank tablets on which the clouds cast shadows that to us looked like faces and dinosaurs and elephants— monkeyshines big as football fields.

A single caddisfly lit on the lake and fluttered dauntlessly there, vanguard of the coming hatch. We tied on our best remaining imitations and fished to the slabby cutthroats. When it got too gusty for casting, we paused and listened to the snapping wingbeats of the grasshoppers or watched the tiny alpine wildflowers tremble in the wind.

After four days, I still hadn't fished the Purple Haze. I'd quit keeping tabs on all the flies except that one. Klaus showed no interest in letting it change hands, but he didn't let it sit idle either. That afternoon, while I stayed campside, he stalked the nearby creeks. When I saw him walking purposefully back at sunset, I figured he had a story to tell.

"It was unbelievable," he said. "I found this stream full of cutties. It's so perfect."

He had trouble finding the words to describe how he'd hooked a succession of fish (one of which he hooked and released twice) on the purple-bodied fly. "Everywhere I went, I hooked up on the first cast," he said. "The very first one!"

I hated to dampen the mood, but I couldn't help myself. "How's the Purple Haze?"

"Oh," he said, his expression darkening. "Well, you gotta look at it." He produced the fly as if it were a tiny, injured bird. I examined it over the top of my eyeglasses. One of the hackles had detached from the head and spiraled out from the parachute. It would not survive another cast—not unless I could maybe tuck the hackle under itself, pull it into a sort of half-hitch and temporarily halt the unraveling.

That night, with hemostats, headlamp and my tongue held at just the right angle, I rehabilitated the Purple Haze as best I could, but at that point, it was held together strictly by fond wishes. It might last long enough for me to land one fish, but Klaus took it back right away and pinned it into his flybox, which now held maybe ten flies and no two alike.

We turned in, and I passed one of my best nights ever in a tent. I drifted off in dreams of Wind River cutthroats gulping that Purple Haze, the only thing we had left that might pass for a Wind Rivers dissertation.

In the morning, Klaus led me to the little waterway where he'd had such success the day before. "It's called Cutthroat Crik," he said over his shoulder.

"It says that on the map?"

"No. That's what I named it."

We came to a shady place where the stream spread out over a bed of cobbles and woody debris. There we stood looking upstream at the backs of three or four small cutthroats idling on their underfins in six inches of water.

"So," said Klaus, without looking at me. "You, uhm, want to try the Purple Haze now?"

Klaus and I are close, and I can read him pretty well. During that week in the backcountry, as we shared our meager fly stockpile, we got closer. If he was an open book to me before, he was now one of those large-print magazines for people with bad eyesight. Even a stranger could deduce the answer he hoped to hear.

"Me?" I said. "Nah. I want to see you tie it on and hook this one on the end here. What do you figure he is? Twelve-incher? Fourteen?"

It seemed Klaus was likewise reading me well enough to know how I'd respond, because he had the fly out of the box and his tippet through the hook eye before I finished speaking.

"You'll have to high-stick him," I added. "Maybe cast from over there."

"No," he replied, wetting the tippet with his mouth. "I know exactly where to go." He cinched down the knot and took up a spot I hadn't noticed, an alcove in the brush close by the bank but hidden from the fish. Then he made a few false casts, side-arming over the water to avoid the understory. His technique was good and I was impressed, but then he got jumpy and sent the line every which way.

Photo by Klaus VanZanten.

"Easy, junior," I chided before he could foul the line or snag a tree. "Get your head together."

He downed his line on the water well back from the fish and ran a hand over his face. Then he looked upstream, lining up the shot. Maybe, without the luxury of a full flybox, we had both grown more thoughtful. I considered the flies I left behind—my offering, my graduate project. I thought about what I'd brought with me instead—and what had been there all along. Klaus began casting again. This time, the line sailed fine and true, and as he fished our last good fly to pieces, he made the offering for both of us.

TO EXPLAIN THE RULES OF MIDNIGHT JUMBO MARSHMALLOW DODGEBALL TAG

One of my greatest hopes is that at least one former Boy Scout out there fondly remembers the time we backpacked into a picturesque sub-alpine valley of the Wind River Range to play a midnight tournament of jumbo marshmallow dodgeball tag. Although I wasn't a great Scoutmaster, and I didn't hold the job for long, it'd be nice to be remembered.

I never wanted to be a Scoutmaster, never volunteered. During the many times I'd backpacked in Wyoming to hunt for big cutties or cast streamers to lake-sized rainbows, the one thing I do not remember thinking is, "Next time I come up here, I ought to bring one dozen children with me."

But the Boy Scouts of America employs a network of spies, and once they identify you as an individual with certain skills—such as how to read a map, shit with efficiency in a primitive setting or tolerate the close and prolonged presence of unwashed teenagers—it won't be long before they extend you an invitation to become a Scoutmaster. It's hard to say no. Because it's flattering. It's as if they're saying, "We want these boys to be more like you. Make them be like you."

So, I worked with Boy Scouts for about five years. I taught them merit badge classes, took them bowling and got between them when fights broke out. We ate from Dutch ovens and shot rifles. It was infuriating. And fun. Funly infuriating.

The first Scout project I worked on was called the "Six-Hour Canoe," a set of plans to build a one-person canoe from plywood, grabber screws

and epoxy. As the name suggests, it was designed to be complete in just six hours, but that assumed the labor of only one person. We had seven or eight Scouts and two leaders at our disposal, so naturally, construction of our Six-Hour Canoe took eleven weeks. And it was seaworthy, provided the water was dead flat calm and the operator didn't do anything reckless, like try to paddle or steer. Sadly, our Six-Hour Canoe's maiden voyage was also its last. We took it to the city duck pond, where everybody got five minutes to float around—carefully—in the shallows. Then we put it in a storage shed, where for all I know it remains to this day.

Other outings followed, but I knew that to be a real leader of Scouts, I had to arrange something grander than kick-the-can or chasing ducks with an eight-foot canoe of dubious stability. To remake the Scouts in my image, I had to plan a journey that would live forever in their memories. I had to lead them into the Wind Rivers.

It wasn't a novel idea. The Wind River Range is a longstanding destination for Boy Scouts. In fact, anyone with an aversion to noisy children in uniforms should avoid the Winds one week before and after July 24, which is when Utah Mormons celebrate Pioneer Day, a state holiday recognizing Utah's pioneer heritage. Every year, on the weekend nearest Pioneer Day, hundreds of Utah Scouts descend on the Wind Rivers, Grand Teton and High Uintah, and the westward migration of Mormon pioneers is commemorated with the largest collective backcountry cat-herding enterprise in history.

Still, as I entered the planning stages, I convinced myself that our trip would be different, if not legendary. To lead a patrol of young men over mountain passes to unknown sylvan lakes where shoals of fish lie waiting. To teach them to live on wild trout and flame-roasted pine nuts. To perhaps glimpse a shambling grizzly bear traversing a distant scree field and, after halting the patrol with a hand signal, to confer with them:

"Patrol Leader Higgins."

"Yes, sir."

"Yonder is a bear. How is he called?"

"*Ursus arctos*, sir."

"Correct. Assistant Patrol Leader Fennimore."

"Here, sir."

"Why must we change course now?"

"Because we are upwind of the bear, sir."

"Correct. Lay in a new course that considers wind direction and the probable path of the *Ursus*."

"Right away, sir."

But when we got into the Winds, here's what I heard instead: "I think I'd like it better up here if there was actually something to do." Chris said that. He was a frail, first-year varsity Scout with the ennui of a kid parted too long from video games. After a day and a night in the Winds, the only thing Chris had gained was a sharper awareness of the emptiness of existence.

"Like what?" I asked him. "What would you like to do?"

"Something besides fishing or hiking."

"Chris, that's what we're here to do," I told him. "What did you think was up here? Go-karts? Movie theaters? Being up here is what you do up here."

"Yeah," said Chris, "that's not actually a thing." He sulked off, hands in pockets, as if consigned to that dreary paradise forever.

A more accurate description of the trip is a bit less romantic than my initial conception and much simpler: to drag twelve kids deep into the mountains for five days and teach them woodcraft against their will.

Not all of the Scouts were like Chris. There was also Zachary, who never complained of boredom because he was content to lope around camp in search of small animals that he might brutally murder. Zachary was gangly and goblin-like, with red hair, freckles and close-set blue eyes.

And Zachary's mortal enemy was the marmot.

The way the big, chubby rockchucks would *pip pip* at us sent Zachary into a state of bloodthirsty wrath, as if they were taunting him personally. He chased them into the boulders with a club, panting his fury through clenched teeth. But the marmots only vanished into their inscrutable stone warrens, so Zachary abandoned frontal assaults in favor of artillery. He'd make a pouch of his shirtfront and fill it with fist-sized clods of granite. Then he'd lob the rocks into the boulders, where they'd clack and crack as the rockchucks ducked for cover. After a few days, I started thinking they really were trying to taunt Zachary into submission—one of them emerged into the open and presented itself as an easy target, but before Zachary could cock his arm to fire, a second marmot went *pip pip* behind him, and Zachary wheeled around so wrenchingly I thought he'd injure his spine. Zachary's aim was too poor to hit any of the marmots, but several stray ricochets came close; I worried that he'd kill one by sheer force of probability. In the evenings, when Zachary finally tuckered out, he sat at the edge of camp Indian-style, glowering at the marmot-infested boulders like some freckled goblin lord plotting vengeance.

Zachary's bloodlust notwithstanding, it's common knowledge that the preferred cure for boredom among Boy Scouts is not murder—it's fire. Not every kid is into killing, but they all love fire. They love poking things into it, dragging things out of it, setting other things on fire with it. Want

Every year, the westward migration of Mormon pioneers is commemorated with the largest collective backcountry cat-herding enterprise in history. *Photo by Chadd VanZanten.*

your Scouts to wake up? Build a fire. Want them to go to bed? Put the fire out. Every boy between age eight and eighteen is an untested and unconvicted arsonist.

Fire also greatly simplifies Scout activity planning. Tell a Boy Scout to go build a campfire, and you will not have to find anything else for him to do for two hours. I once saw a Boy Scout hold a wooden match to a thigh-sized log as if it would catch fire like a candlewick. When it didn't, he lit a new match to try again.

Once the campfire is lit, which is to say once you allow the use of lighter fluid, some adult supervision may be called for.

"Michael, stop. What are you doing? Stop."

"Just gonna stick this in the fire."

"What is it?"

"Piece of a busted plastic from a backpack frame. I found it by the trail."

"Why are you sticking it in the fire?"

"I just wanna see what happens."

"Okay, listen: that's never a good reason to do anything."

I wasn't alone supervising this forlorn, murderous, arsonistic expedition. In fact, I wasn't even first in command. I was merely the trip consultant, the guy with the route, timetable and meal plan. Our leader was Lynn Rawlins. He was in his early fifties, maybe ten years older than me, and he was an experienced and well-known Scoutmaster. Lynn was an Eagle Scout, had probably been a Scout leader for most of his life and wore a Scout uniform to even the most informal Scout gatherings. I liked him anyway.

But although Lynn's rote knowledge of Scouting and woodcraft was unquestioned, he seemed a little short on practical experience in alpine living. He was also somewhat doughy and noticeably panda bear–shaped. We'd had to plan a comparably easy hike to accommodate his bad knees, ankles and several of his vertebrae.

"My hips hurt, too," he told me.

On the morning we left for the Winds, I met Lynn at the church parking lot we'd chosen as our staging area. I was half an hour early, but Lynn was already there.

"Morning, Lynn," I said. "Ready for this?"

"Oh, I suppose," he said with a shrug and grin. "Knee's been acting up. And my hip."

Pajama-clad parents began rolling up in SUVs to drop off their sleepy Scouts. Lynn greeted them, assured them that he'd bring their sons back "in at least one piece" and laughed at the joke when they didn't. While he collected their permission slips and presided over their goodbyes with his annoying, avuncular warmth, I stacked their backpacks in the bed of my truck.

The last pack caught my eye because it was a top-shelf model—a pro's pack—but it was tragically heavy. "Good lord," I said, bringing up my knee to buck the pack into the truck. "Whose is this?"

"Oh, that's mine," said Lynn, shading his face with his clipboard. "Like it? It's nice."

"Lynn, it feels like it's filled with sand."

"You think?" He slapped the pack with a zesty, pre-trip bravado, but then he frowned. "I put it on last night and it didn't feel too bad."

I tugged the pack off the pile and onto the open tailgate. "Put it on for a sec."

Lynn slipped his arms through the shoulder straps. When he lifted the pack from the tailgate, he lurched backward with the weight and then stood bent forward to keep it from flipping him on his back like a turtle.

"Looks like it's on the heavy side," I said. "Sure you don't have anything extra in there? Like a car battery?"

He chuckled.

"Did you weigh it?"

"Yeah."

"And?"

"Sixty-eight pounds, give or take. That may have been before I put my water in, though."

The first thing we pulled out of Lynn's pack was a medical kit the size of a lady's purse. Not the slim, sexy clutch a young lady might carry, but the roomy, shoulder-mounted deployment sack that a mother of five lugs around. Inside the kit were ACE bandages, Bactine, burn cream, paramedic scissors, whole bottles of pain reliever and enough gauze to build a pretty good kite. Over his protests, I told Lynn to pick out a few essentials, and we set the rest aside.

Next out of the pack was an actual mallet for driving tent pegs. "We use rocks, Lynn," I scolded. "And they're already up there."

He laid aside the mallet.

Next was a small metal hook with a T-shaped handle, like a miniature fishing gaff.

"What on earth is this for?" I said, holding the thing up.

"Tent-stake puller," said Lynn.

I sighed.

Lynn took the hook from me and tossed it onto the discard pile.

It wasn't difficult to sympathize with Lynn. I had made all the same mistakes myself. On my first trip, my pack weighed the same as his—I brought a book, binoculars, a garden shovel to dig cat-holes and even a miniature chess set. I'd since cut my pack weight to nearly half what it had been—even chopped off the handle of my toothbrush—but I was well acquainted with the impulse to bring everything, just in case. Among his foodstuffs, Lynn had two big bags of marshmallows.

"Lynn, seriously? These are a pound apiece. Do you know how hard it is to shave a pound of weight from a backpack?"

"Ahh," scoffed Lynn. "I only have to pack them in. They'll be gone the first night. It's a camping trip. You can't go camping without marshmallows."

"No marshmallows."

Our hike into the Winds bore only the merest resemblance to what I'd envisioned. We did not march up the trail in single file with Lynn leading the way like Fred MacMurray in *Follow Me, Boys!* And we did not sing "The Happy Wanderer." Not even once.

Instead, the patrol stretched into a ragged string of subgroups. In the lead were the Scouts who had packed light and walked fast. A few minutes

behind them came slower, successively sweatier groups, consisting of Scouts who tired faster and were prone to dawdling.

Behind everyone was Lynn, sweatier than the rest combined. He lumbered up the mountain, adjusting and readjusting his pack. I checked on him a few miles in. His glasses had slid down to the end of his sweat-slick nose. He pushed them up and said, "This looks like a good spot for a rest break." I couldn't disagree—he was only fifty yards from where he'd taken his last one. Despite our attempt to lighten his pack, it was still too heavy. He sat down in a heap and guzzled water, legs splayed out across the trail.

Meanwhile, every mosquito in Wyoming had mounted a coordinated attack on our column, the brunt of which was being absorbed by one Scout whose name was Bryan. To be fair to the mosquitoes, Bryan was asking for it—he had not worn the long-sleeved shirt and long pants I had pedantically prescribed, and he'd neglected to bring the head-net and 100 percent DEET bug spray I'd included on the packing list. Truthfully, we were secretly happy to have Bryan along that year as a decoy for the rest of us.

I wagered that the mosquitoes would thin out when we'd gained some elevation, but as we arrived at our campsite, someone pointed at the lake and asked, "What is that? Fire?"

Gray plumes of smoke hung strangely over the swampy shoreline and bankside alders. Not the white mist that rose ghostly over the alpine lakes on cool, calm mornings, but a blackish haze that surged and retreated. But I didn't have to look to know what they were asking about.

"Mosquitoes," I said. "It's mosquitoes."

Before sunset on the first day, Bryan's skin was blotchy pink and had taken on a uniformly bumpy texture. His neck, fingers, lips, eyelids—all bumpy, like some hideous creature effect in a horror movie. He got so bitten and raw I considered taking him off the mountain for medical care, and I had nightmares about what his parents would say when I dropped him off at home.

I told him, "Bryan, we can find you a long-sleeved shirt. Taylor says he's got an extra one."

Bryan shrugged and waved off the mosquitoes swarming around his disfigured face. "Nah, I'm okay. They really don't bother me."

A kid named Jake was the closest thing I had to the dutiful, heel-clicking patrol leader I'd imagined, but he wasn't athletic or outdoorsy. He was thin and pale and wore a lot of black clothing, with black-rimmed eyeglasses and a shock of black hair that fell over his eyes. Jake played drums in his high school jazz band—Donald Fagen as a Boy Scout.

On the drive to the trailhead, Jake had eloquently explained to me the difference between "wet" and "dry" drum sounds and how to identify various drum attacks. As we crossed into Wyoming, we passed the AUX cable back and forth to play samples of our favorite music—Led Zeppelin, Neutral Milk Hotel, The Specials.

"I've heard some of Joy Division's music," said Jake, placing a finger on his chin. "Didn't they break up and start New Order?"

"Joy Division became New Order after the lead singer killed himself."

"Oh, bummer."

Jake and I shuttled between the groups to make sure nobody strayed off the main trail and to periodically ensure that Lynn was still alive. Eventually, we made it to the campsite, but Lynn was wiped out. He came into camp on shaky legs, dead last and pasty-looking. For most of the rest of the trip, Lynn stayed in camp, apparently hoping to convalesce in time for the hike out.

And so it fell to me to keep the patrol entertained. On the morning of our first full day in camp, as the Scouts stowed their cooking supplies, I asked, "What do you guys want to do today?"

"What are the choices?" asked Chris.

"We could fish," I said, showing them the fly rod I was already holding. "Anyone want to fish?"

A few of them raised their hands. Jake and Taylor had already mentioned how they wanted to learn more about fishing. Michael and Zachary were in—both passable anglers. Bryan put his bug-bitten hand in the air but then lowered again. A few of the others just shook their heads.

"What else is there?" asked Chris.

"That's most of my list," I said with a shrug.

Lynn had planned to lead day trips up to a few nearby peaks, but these were canceled and replaced with simpler, in-camp affairs such as Bird Watching from the Seated Position, Foraging for Very Nearby Wild Edibles and other activities that the boys easily recognized as educational and, therefore, punitive.

We had chores to do, too. Every day there was firewood to gather, water to filter and cook pots to wash. To avoid attracting bears, all the food was placed in a backpack and hung from a tree branch far away from camp, and this had to be retrieved, lugged to camp and then hoisted back up the tree.

"If you're coming with me," I said, "it's gonna be hiking and fishing. Lynn's gonna do some fun stuff, too, but it's mostly gonna be walking here or there and looking at stuff."

"Can we build a fire?"

"It's a little early in the day for a fire, Chris, and it's gonna get into the high seventies today anyway. Why don't you come with us? Big fish—many as you want. If it gets warm enough, you can take a swim in the lake. There's a waterfall."

Most of them came along—Chris grudgingly, but Jake jogged nearly the entire way. We fished a finger-shaped lake in a narrow valley. Along one side was a shoreline of boulders, and on the other was the steeply sloped granite hip of a mountain. The inflow came in over a cliff, a hissing waterfall fed by snowmelt and glacial runoff from somewhere higher up. The outflow fell into a ravine, where the water cascaded noisily down through a series of cataracts.

The sun shone out that day while fleeting thundershowers rolled through benignly. As we approached the lakeshore, even from a far distance, the golden torpedo shapes of cutthroats could be distinctly seen against the turquoise and indigo depths of the lake. We'd climbed another five hundred feet, and so although there were no mosquitoes, Bryan appeared to enjoy himself anyway.

Only a few of the Scouts really knew how to fish. Most of the rest brought fishing gear that was broken down or snarled up. Lynn and I unbuggered every reel in the lot. Some of the gear worked fine but wasn't very suited to the region. One kid packed an enormous, chrome-plated, bait-casting outfit that I imagined had last seen action on a charter vessel plying the swordfishing grounds of the Pacific Ocean. But with a little fixing and mixing and matching, we put together serviceable fishing outfits for those who were serious about catching fish.

Once fishing commenced, the Scouts required quite a bit of assistance. One or another of them snagged a tree approximately every ten minutes without interruption. When there were no living trees nearby, they'd snag on fallen trees submerged in the lake. They snagged on each other and, almost as often, on themselves. I helped Taylor unhook a big angry treble hook from the seat of his own pants, turned away for one minute to help someone else and found Taylor had hooked his drawers again. No one lost an eye to fishhook mishap, but I have no explanation for that.

Fortunately, the trout of the Winds are very patient with novice anglers. Lures of almost any color or design will elicit passing interest from Wind River trout, and casting with finesse is not always necessary. The big Rapalas and Daredevles the Scouts brought made big splashes, and lots of big cutties came chasing. They didn't always hit and when they did they didn't always stay hooked, but it was exciting to watch them race through the clear water to investigate.

Reefs of wet, grainy snow still lay on the north-facing slopes that year, so we put a dozen or so of our catch on ice in plastic grocery sacks to pack them back to camp. For supper, we slathered them with butter, wrapped them in aluminum foil and cooked them on the campfire.

I kept at this regimen as best I could. In the morning, I'd clank on my cookpot with a spoon to wake everyone up, and a few Scouts would resign themselves to come with me. I'd stand by the trail, fly rod at the ready, checking my watch as the Scouts listlessly yanked their boots on. Then I'd take the lead, trying hard to show them the way of the backcountry angler, as though I were some ranking member of that species.

We caught fish every day, of course, but never with much conversation and not even very much interaction. It helped that Lynn rallied to lead a few short excursions of his own to add some variety, but we nonetheless brooked a steady stream of complaints about boredom.

Greater than the problem of their expectations was that of my own. I expected the Scouts to have transformative, even transcendental experiences. I assumed they'd respond to the place the same way I did, especially with respect to the fishing. We caught fish and we had some laughs, like when Taylor dropped his fishing rod in a lake and had to strip to his skivvies to fish it out of the bone-chilling water. But Zachary mostly chased marmots, Michael burned things and Bryan grew bumpier. Chris remained steadfastly unmoved, and even my man Jake often participated with the weary obligation of a traffic school student. The others were much the same, exhibiting dim sparks of interest between long stretches of something that almost perfectly resembled apathy. By the evening of the third day, they were fantasizing about real beds, real food and real toilets.

On the final full day of the trip, the weather was warm and sunny, but I couldn't get any of the Scouts to heed my call, so I went out without them. As I returned, the sky was an expanse of improbable coral shades that deepened with sunset to burgundy. Night fell quickly and the stars emerged, bathing the camp in a fuzzy, silver glow.

At the fire pit, the Scouts drank cup after cup of hot chocolate. Lynn had brought too many cocoa packets, so he ordered everyone to boil it up and drink it down so he wouldn't have to pack it out.

"I'm going to LaBeau's for a pastrami burger," said Michael, sipping at his mug. "With onions. And mushrooms. And bacon. And onions."

"I just want pizza," said Zachary. "As in a pizza."

"Hey, guys," I said. "Let me show you one of my favorite things about this place: satellites."

A few of them looked in my direction.

I gestured at the sky. "See, since we're so far away from city lights, you can see the stars better out here. Every star, every planet, every thing—including satellites."

They looked upward, mouths gaping.

Even in a small city like the one where we lived, light pollution minifies the night sky to something like a "best of" album. Only the brightest stars are clearly seen, with hazy voids of night between. But in the wilderness, on clear nights at ten thousand feet, the stars show out like luminous vapor. It's difficult at times to pick out even the most well-known constellations, and you understand where the name "Milky Way" came from—it's not a band of tightly packed stars so much as a great river of molten starlight. And if you watch closely, you will begin to see the satellites moving like fugitive stars through the night.

"I don't see anything," Chris complained. "Well. Except stars."

"Keep looking. Look for one that's moving."

"Is that one?" said Zachary. "Right there?"

I looked where he pointed. "Yes. Here, guys, see? Oh, and there's another one."

"Oooh, yeah." They nodded, pointed.

"How fast are they going?"

"Fast," I said. "Thousands and thousands of miles per hour, I think." We spotted a few more. It was a good night for satellites.

"I thought you meant we'd be able to actually see them," Chris lamented. "Not just lights."

"Chris," I said with a sigh, "they're a couple hundred miles up. They're so far up in orbit, that's all you can see—sunlight on their solar panels."

"I just thought you meant we'd see the actual satellites." He was a hard one to reach, but then again, the rest of them stayed interested for only a few minutes longer.

Just before he went to bed, Lynn stepped grinning into the firelight with both hands behind his back. The flames shown cheerily in his eyeglasses. He stood there like that until he had everyone's attention.

"What have you got?" asked Michael, straightening. "Please let it be marshmallows."

"Well, it is our last night," said Lynn, revealing the one-pound bags of marshmallows. The Scouts scattered in all directions to fetch sticks to roast them. These were the jumbo-variety marshmallows, nearly the size of apples. The boys returned within a minute, whittling their sticks and tearing at the bags like little jackals.

Most of the first batch of marshmallows caught fire and were for all intents incinerated, but the Scouts ate them anyhow. With half the marshmallows gone, the next round was prepared with more care and lingered over with relish. Jake showed us how to brown a marshmallow, peel and eat the skin, and then brown it again, peeling and eating the husks until nothing remained. They held a contest to see who could peel the most marshmallow skins. I think the record stood at seven.

The Scout patrol had seen hundred-mile vistas from granite overlooks above treeline. We'd watched bachelor stags topping stony ridges, and we'd seen pikas, those elusive alpine rodents most people didn't even know about. We'd landed three-pound trout. But apparently all they really needed to enjoy themselves was a few sacks of marshmallows, the very thing I'd told Lynn not to bring. As I pulled another husk from my marshmallow, I realized maybe that was okay.

Soon the marshmallow-and-cocoa glucose boost turned the Scouts giddy. Bryan got particularly riled up—having lost so much blood to mosquitoes, he was perhaps more susceptible to the rapid infusion of sugar. He found a marshmallow on the ground, apparently the last remaining. The others dared him to eat it, and he nearly did, but it was evidently too dirty even by Scout standards. So he instead hucked it hard at Michael. The marshmallow struck Michael with a loud *pop* and then fell into the sooty dirt by the fire pit. Michael picked it up and fired it back at Bryan, and so the marshmallow flew back and forth across the fire from kid to kid. Each time it found its mark, it went *pop*. The boys laughed and hollered.

"Let me see that thing," I said.

Someone passed it to me. I switched on my headlamp. After repeatedly falling in the soot, the soft, white surface of the marshmallow was now a dark and leathery hide, which felt strangely durable. It was like a squishy lump of coal or an all-black hackey sack. I chuckled and tossed the thing back to Bryan. They started up again, dodging it or leaping to catch it. Soon they were raising actual hell, the kind that sugar-high teenagers will inevitably raise. They scrimmaged and wrestled in the shifting shadows, stumbling into the fire at times, sending up columns of sparks.

Lynn had distributed the marshmallows and promptly fled to his tent for the night. I rubbed my face.

"Simmer down," I ordered. "One of you is gonna end up on fire. Or worse—you'll melt your boots." The boys settled down for a few moments, but then one of them slyly pitched the marshmallow across the flames again. It struck with its peculiar *pop*, and the clowning resumed.

"Enough," I barked. "Give me the damn marshmallow and go to bed. All of you."

"We're not tired," Chris protested. "We're actually having fun." The others murmured their agreement. I looked at Chris. Even he'd finally found something to do in this three-thousand-acre purgatory: playing with a filthy marshmallow.

"Fine," I said. "But get away from this fire. And keep the noise down. You've got thirty minutes. Then bed." The Scouts shuffled a few yards out from the fire pit, but something had changed. I hadn't thrown water onto the fire, but they acted like I'd thrown big buckets of ice water on all of them. They began to mope away.

"Wait," I said. "You can still play with your marshmallow. Play dodgeball or something with it. Out there. Or maybe tag. Dodgeball-tag?"

They stood there listening. For what might have been the first time, they stood listening to me, all of them, awaiting instructions. My song-worthy Scout expedition to the Wind Rivers had come down to this. The maps, planning and gear checklists had all led to one final critical task: to explain the rules of the world's first midnight jumbo marshmallow dodgeball tag tournament.

"Understand?" I continued. "You pick up the marshmallow and throw it. If you hit somebody, they're it. If they hit you, you're it. It's dodgeball, but with tag."

"It's too dark."

"Get your headlamps," I said.

"What are the teams? Where's the line?"

"No teams," I said. "No teams and no lines."

"Can we hide?"

I considered this. They would at least be quiet if they were hiding. "Yes. Hiding is permitted."

"Can we tag with the marshmallow? Like in baseball? Or do you have to throw it?"

"You have to throw it. If you guys start trying to make contact, someone will crack their skull."

And that was all they needed. Just a little order, the outline of a construct. They began.

Our last night in camp was filled with shrieking and headlamp beams wobbling in darkness. I drank some cocoa and watched the game from the fire pit. The half-hour time limit came and went and then came and went again.

Photo by Klaus VanZanten.

These Scouts certainly did not see the Wind Rivers the way I did, but they'd nevertheless found the place they were looking for—a vast and vaguely hazardous playground, dark and largely uncivilized. And I hadn't remade a single Boy Scout in my image, but why had I wanted to? That night, they were finally themselves—wild, sweaty despite the night's chill, running at full gallop through the backcountry shadows like some tribe of primitives.

Beneath the crisscrossing satellites, the game only got faster and louder. I went to bed. As I lay in my sleeping bag, Scouts thundered past my tent. At least one of them jumped clean over it. The playing field expanded until it encompassed the whole hillside, and as I dozed off, I dreamed the entire mountain range was in play.

A FISH OF THE WIND RIVERS

The fish of the Wind Rivers don't ask much. They don't require precise fly imitations or championship casting. If you've got a fairly suggestive fly, tied with care, and your cast is not a complete embarrassment, a Wind River trout probably won't turn you down. If they're sipping midge emergers from the surface film and you open your flybox and the best you can do is a Day-Glo green size 10 Chernobyl Ant, tie it on. All reasonable offers will be considered.

My son Klaus and I once spotted a Wind River brook trout of about eleven inches perched at the top of a pool where the water spilled over what looked like a half-hearted beaver dam. I covered the fish with a caddis pattern, and the brookie took a swipe at the fly as soon as it touched down. This happened almost too fast to see—one moment the fish was motionless, the next he was a silvery splash. Then he was holding in the current again. All I knew was he missed the fly, so I left it on the water, and the fish came back. This time, I saw him rising, but I must have tensed or flinched because I inadvertently repositioned the fly and the fish missed a second time. By now, the fly was almost at the tail of the pool, and it had come under the influence of some drag that I couldn't mend out. The fly was making a pronounced "V" shape in the water, and in another two seconds it would drop out of the pool. But the brookie came back, came straight at the fly, and in so doing saw me. He flicked away, and I thought the jig was finally up. But the jig was not up. The fish came a fourth time and plucked the fly from the tailout just as it was sliding from the pool.

This is your basic Wind River trout.

I don't mean to imply that all fishing in the Wind Rivers is easy. There are times when you must absolutely cast well, choose your fly thoughtfully and maybe even crawl on your belly. And you must, obviously, go to them. This means packing supplies for five or six days and walking under that load for half a day until you're deep in the woods. The air will seem cleaner but much, much thinner. There may be snow or there may be mosquitoes— oftentimes both. You must sleep on the ground, collect and filter drinking water and choke down protein bars that taste like strips of carpeting dipped in wax.

There are ways to get to the Wind Rivers that don't involve backpacks. You might hire a drop-camp teamster to lash all your gear to a pack animal so that you don't have to carry it. For a little more money, the teamster will lash you yourself to the animal so that you don't have to walk at all. You may pay other hirelings to put up a tent and cook for you, too, but whether you make these efforts or pay someone else to, the obligations will be met before you cast to a single fish.

You might not remember that first one. Your first Wind River fish will likely be lost in your memories among the many others you catch that day. The first big fish, on the other hand, will probably stay with you longer, mainly because you'll probably catch lots of the small ones beforehand.

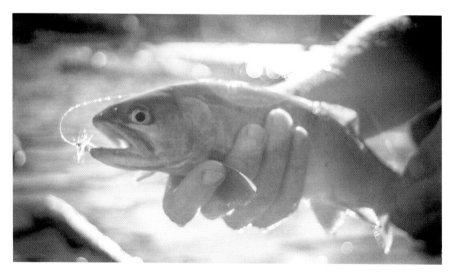

If they're sipping midge emergers from the surface film and you open your flybox and the best you can do is a Day-Glo green size 10 Chernobyl Ant, tie it on. *Photo by Klaus VanZanten.*

The ten- and twelve-inch fish are like sentinels, allowing you to pass on to the lakes and streams that hold the big fish only after you've hiked farther, climbed higher or blazed your own trails.

Wind River trout are of many species—most of the trout species are represented, in fact. Rainbows from the West Coast, brook trout and lakers from the East Coast, brown trout from Eurasia and even grayling from England and France. Golden trout of trophy size are rumored in some drainages. It's what my friend Brad, an environmental historian, would call a "smorgasbord fishery."

You'll find a buffet of cutthroat, too, but only the Colorado River cutthroat is native to the place—and it's highly unlikely there are any left up there that are genetically pure. All the cutthroats with the morphology of Bonneville, Yellowstone or westslope cutthroats are descended from out-of-towners. The first few times I fished the Wind Rivers with Klaus, he was still learning to tell them all apart.

"Let's see," he said, eyes narrowing at the fish recovering in his net. "This is a—cutthroat. Is that right?"

"Rainbow," I corrected. "The spots go all the way up onto his head and face."

"But he's got the red cuts."

"Some rainbows have that. Probably a hybrid. Cuttbows, they call 'em. The spots are a giveaway. Close enough, though."

After a few trips to the Winds, I had wondered how these varied and assorted trout species arrived in the same remote mountain range, hundreds or thousands of miles from their native waters and a long way even from the nearest paved roads. How were they assembled this way?

Once I started wondering, it wasn't long before I heard the name Finis Mitchell. The "Man of the Mountains," the "Lord of the Winds"—Finis (rhymes with "highness") Mitchell is shrouded in legendry. I would like to say that he was revealed to me like a backcountry lake, first glimpsed through mist and crooked lodgepoles, becoming clearer as I rounded a bend in the trail, but it wasn't that dramatic. I was having lunch with a friend at a fast-food place.

I said, "I'm heading to the Winds next week."

"Oh, really?" asked my friend. "Hey, do you know much about Finis Mitchell?"

"Finis who?"

"Mitchell. He's the guy who supposedly stocked all the Wind River lakes with trout back in the '30s."

"No," I said. "Never heard of him."

"He wrote a book about it, how he populated the whole place with trout by himself. Supposedly carried them up in buckets on horses."

I didn't look for the book right away because it was time for my trip, but while I was up there, quizzing Klaus on trout morphology, I thought about the fish. Rainbows, brooks and cutts—all caught on the same day.

"These are all brook trout, right?" asked Klaus. We hadn't started fishing yet. He was looking at the fish in the stream.

"Yep."

"Those white stripes on the fins," he said, pointing.

"Yeah, and orange bellies."

So, I thought, all the nonnative fish we catch must be descendants of a finite set of fish put there by some guy with the improbable name of Finis. What did that mean?

The book is called *Wind River Trails*. It was the first-ever guidebook of the region and is said to have been very popular upon its release in 1975. I bought a copy shortly after I got back from my trip. Without remembering the full title or name of the author, it took mere minutes to look up and order it, and it cost only a few dollars. Even so, it's definitely not as well read now as it was when it was new. I've met people who've been tripping to the Winds for years who have never heard of it.

Although *Wind River Trails* contains hiking and fishing information about most of the major drainages in the Bridger Wilderness, the book is quite dated. Even the most recent edition is almost twenty years old. The formatting and illustrations have a clunky, DIY aesthetic—it appears to have been typeset on an electric typewriter, and the maps are photocopies of pencil sketches. All of the writing is Mitchell's own, and it's full of poor grammar and fractured prose. Scattered throughout the trail descriptions you'll find verses of Mitchell's poetry and homespun aphorisms like this one: "Too many of us follow endless trails. Unless a trail leads somewhere and ends, it is but a circle."

Not exactly the sound of one hand clapping. This high-country fortune cookie fodder at first led me to think that Mitchell was keen to pad out certain parts of the book, but it didn't take long to realize he was simply in love with the place. I've committed sins that grave while writing about the Wind Rivers, and I've had some formal training. Mitchell's writerly transgressions can be overlooked where mine can't, not only because his writings include technical information that is still somewhat relevant but also because the story between the lines of *Wind River Trails* is astonishing (though not always in a good way).

It begins more than one hundred years ago with Mitchell heading to western-central Wyoming with his family. His father, Henry, had traded a 40-acre spread in Missouri for 160 sight-unseen acres beneath the west-sloping peaks of the Wind River Range, much of which would one day become the Bridger Wilderness Area.

Back in 1986, the late James "Randy" Udall, renowned backpacker and environmental activist, wrote a sprawling Finis Mitchell retrospective for *Audubon*, where much of the saga is captured in Mitchell's own words.

"We came west in a boxcar," Mitchell told Udall. "Had everything we owned in there. Wagon, two mules, cow, dog, household goods. Got to Rock Springs, Wyoming, on April 26, 1906."

Mitchell was five years old at the time, but he recounted the trip to Udall with colorful, folksy clarity. From Rock Springs, his family "[h]itched up; headed north. That sagebrush desert was so lonesome, one of our mules got homesick and died. Took us a week to get there. Melted snow for water; ate sage hens." Unfortunately, they soon discovered that farming the arid Wyoming soil would probably not pan out. "Dad's land was worthless—nothing but sand."

Finis's mother was devastated by the apparently bleak prospects and wanted to go back to Missouri right away, but Wyoming was not completely barren. The Mitchells were able to hunt, fish and trap in the Wind River foothills to help feed themselves.

At that time, the Wind River Range and other western federal lands were in a perplexing, nearly constant state of governmental administrative flux. At the turn of the century, before the Mitchells came west, the federal government had given the Wind River Range very little special distinction. It was just a remote, undeveloped mountain range. Then, in 1902, President Theodore Roosevelt annexed the Winds into the Yellowstone Park Timber Land Reserve, which was the wild, impervious borderland originally established around Yellowstone proper in 1891 by President Benjamin Harrison to buffer the park against clearcutting and overgrazing.

About the time Henry Mitchell was mulling his family's boxcar exodus from Missouri to Wyoming, an obscure piece of legislation entitled the U.S. Transfer Act of 1905 removed the Wind River Range and the rest of the Forest Reserve system from the General Land Office (which later became the Bureau of Land Management) and gave it to the Division of Forestry (which was thereafter called the U.S. Forest Service).

That arrangement lasted only two years. In 1907, Roosevelt changed the designation of "Forest Reserve" to "National Forest," and the Wind River

Range became part of the Yellowstone National Forest. A year after that, Yellowstone National Forest was divided into smaller units, and the Wind River Range became a part of the Wyoming National Forest, a designation it held until 1941, when it was re-designated as its own place named the Bridger National Forest.

And, finally, with the passage of the U.S. Wilderness Act of 1964, a boundary was drawn tightly around the Wind River Range west of the Continental Divide, and they designated it the Bridger Wilderness Area, now part of the Bridger-Teton National Forest, which was formed in 1973 by combining the Wyoming National Forest and Teton National Forest. Fortunately for those of us with a distaste for federal bureaucratic history, the Bridger Wilderness Area has remained so since that time with only a few minor adjustments.

This flurry of legislation and name changes leaves the impression that the federal government was awakening to the pricelessness of its wild and open spaces but was at a loss about how best to monetize such resources while also safeguarding them from exploitation and ruin. To me it resembles a sort of gleeful terror, perhaps not unlike that of the pauper who discovers the rock he's been using as a doorstop is actually a meteorite of immense worth.

The impressiveness of the land was never lost on Finis. He said that when he was a boy, he'd prayed for his father to be unmoved by his mother's pleas to return the family to Missouri. Think about that. So deep was his infatuation with the Winds, he asked his god to ignore his own mother's anguished homesickness for a chance to go "into those massive mountains."

Apparently, Finis's god listened, and his chance soon came. "I still haven't forgotten my first look," said Finis of the first time he gazed into the range after summiting one of the smaller peaks with his father while hunting elk in 1909. "It must be the beauty of the land."

I have no problem recalling my first looks, either, hiking in with Klaus almost one hundred years after the boy Finis and his father did so. Klaus was wiry, fit and had packed light. I was heavy, sluggish and so inexperienced that I'd packed no less than seventy pounds of gear and provisions. Klaus took the trail effortlessly, staying far ahead of me for most of the hike, but I caught up to him at a high overlook, where we lingered, awestruck witnesses of our own minute presence in the craggy landscape of gray and blackish-green.

Without viable farmland, the Mitchell family turned to other livelihoods. They hauled freight for a penny a pound and worked for the mining industry in Rock Springs. Finis, now in his twenties and a strapping six-footer, went to

work for the Union Pacific Railroad in 1923. However, when he was laid off in 1930 at the beginning of the Great Depression, he found himself again seeing the Winds for more than their exquisite peaks and sweeping vistas.

"When we got laid off, that was it," said Mitchell. "There was no unemployment compensation. There was no jobs, period, even for beggars. I went up into the foothills to trap. Emma and I ate a lot of beaver that spring to keep our belly buttons from rubbing agin [*sic*] our backbones."

In 1930, Mitchell went into business for himself, guiding trips to Mud Lake, near the Big Sandy Openings, on a Forest Service lease. "A friend suggested we open a fishing camp," he said. "Hell, we didn't have nothing else to do."

Mitchell and wife Emma ran the camp. The guiding services were free; they made money by charging for meals and renting out horses that they'd borrowed from locals. "I had lived here since 1906 and I knew everybody," said Mitchell. "We managed to borrow ten horses with six saddles and four pack saddles. We charged a dollar and a half a day for the horses."

Those amounts may sound paltry, but for the Mitchells it was a living. "Believe it or not, that first summer we made three hundred dollars and fifteen cents," he said. "You'd be surprised at how many people would like to eat with us."

Mitchell's camp was located in one drainage of this enormous wilderness, which comprises about 120 miles of the Continental Divide, approximately 800 miles of stream and no fewer than two thousand lakes and ponds. The lowland state of Minnesota is known as the "land of ten thousand lakes," but Wyoming surely has legitimate grounds to protest that honorific. Topo maps of the Wind Rivers have a lacy appearance, owing to the highly rugged terrain beset with multitudinous waterbodies, which range in size from hundreds of acres down to just one or two—those little ponds that John Gierach provocatively termed "anonymous blue dots."

In the early 1930s, the vast majority of these lakes and the anonymous dots were uninhabited by trout. "When we set up our fishing camp, there were only about five lakes that had fish in them," said Mitchell. "These were all cutthroat trout, native to the Rocky Mountains."

Mitchell understood why the Winds were largely barren of trout—the glacial drainages form high-gradient streams interrupted by numerous falls that prevent fish passage to higher elevations. Cutthroat trout evolved from oceangoing salmonids on the West Coast of North America a few million years ago, and for millennia they have pressed eastward into the Rockies by way of the Snake River and other large drainages. However,

until Mitchell came along, they could not encroach the upper valleys of the Wind River Range.

Mitchell also knew what the barren lakes meant for his enterprise. He was desperate for income, and more species of fish in more lakes—especially species that grew large and fought hard—would translate into more fishermen and business at the camp. And so, to enrich the fortunes of his tiny fishing camp, to keep bread in his belly and a roof over his head, Mitchell took several million years of natural history into his own hands.

It began innocently enough. Mitchell captured seventeen wild cutthroats from Big Sandy Lake and transplanted them in nearby fishless lakes. This may not seem like the groundwork for staggering environmental change; Mitchell merely assisted a few bucketfuls of trout in traversing what was probably only a few miles of dry land. But the planted fish had been unable to reach those upper lakes on their own for hundreds of thousands of years—Mitchell made them nonnatives within their own range.

And then the enterprise expanded exponentially. Mitchell said that "a man from the hatchery drove out and asked us whether we'd be willing to pack trout into the mountains, free. We was tickled to death. Fishing was our life, see."

With that, Mitchell became the de facto, self-designated agent of the Wind Rivers bureau of the U.S. Department of Agriculture, ordering increasingly more fingerling trout of all kinds from the Wyoming Board of Fish Commissioners, which at the time was eager to stock its many waterways with fish. "The hatchery brought fish to us in five gallon milk cans, twelve cans at a time," Mitchell reported. "They were an inch long, a thousand to a can.…We would put these twelve cans on six pack horses, a can on each side and pack them into the mountains."

Mitchell explained that the endeavor was more complicated than he first made it sound. The mouths of the cans were covered with burlap so that the water could be aerated by sloshing about, but this meant that the horses had to be kept moving all the time. Even during the loading process, the horses were walked in circles to keep up the jostling, and the cans had to be refilled along the trails, some of which were twenty miles long or more. There was doubtless some mortality among the fingerlings; it's hard to believe any of them survived.

But they did. "The first fish I caught was a four-pound male," Mitchell said of his initial visits to inspect his crops. "Bucks we called them. He was a monster. He looked like you had blown him up with a pump. My dad said I better turn him loose because it was possible only one buck had survived.

So I turned him loose and went around a couple of hundred feet and caught another buck, and he weighed five and one-half pounds."

After our first few visits to the Wind Rivers, Klaus and I found out that it would be difficult to exaggerate how good the fishing is there. It's nearly impossible to ever be skunked, for one thing. There are streams and lakes in literally every direction, and most of them are populated by trout that are woefully gullible—the fish most commonly decide whether to eat your fly by going ahead and eating it, apparently working on the assumption that they can spit it out if it disagrees with them. Lakes containing three-pound trout are not difficult to locate, and if they're harder to reach, that only means you go to more beautiful places, which makes fishing them even more exhilarating.

However, one gets a distinct sense that the best Wind River fishing probably occurred while Mitchell ran his fishing camp, when all of the new populations were booming. Some lakes and streams once known to produce large fish are now either fishless or overcrowded by very small fish, as populations of large trout collapse in the unbalanced ecosystems. Subsequent generations, if any can rise up, can get trapped in smaller size classes.

With the benefit of Mitchell's human-made biome of transplanted trout, his fishing camp survived and even prospered for a while—Mitchell eventually hired his father and brother to help. Plowing western Wyoming's miserable soil may not have paid out for the Mitchells, but farming its waters did.

They ran the fishing camp until 1938, when Mitchell was rehired by Union Pacific. But even while getting a regular paycheck from UP (and after he retired), Mitchell maintained his self-appointed position as a one-man chamber of commerce for the Wind Rivers. For decades, he wrote articles and gave presentations about the Bridger Wilderness, revealing it to the public but also touting his own accomplishments—twelve cameras worn out by snapping an estimated 120,000 Wind River photos, 15,000 miles of Wind River trails hiked and 276 Wind River peaks summited, many of them numerous times. The U.S. Geological Survey sent Mitchell draft versions of its topographical maps for verification, which he reportedly corrected solely from memories of hiking and climbing there. He climbed one particular peak so many times, and was considered such a valuable resource, that the USGS temporarily lifted its injunction against naming landforms after living people and gave Congress clearance to dub the 12,482-foot mountain Mitchell Peak.

"I told them I was half-dead anyway," Mitchell quipped.

Mitchell served as a member of the Wyoming House of Representatives and kept hiking and climbing the Winds well into his old age.

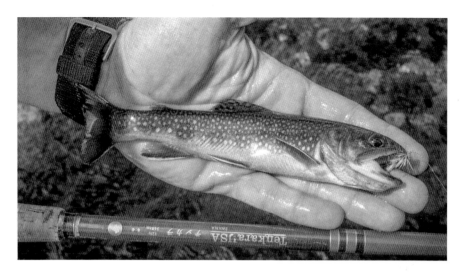

Some lakes and streams once known to produce large fish are now either fishless or overcrowded by very small fish, as populations of large trout collapse in the unbalanced ecosystems. *Photo by Klaus VanZanten.*

It bears mentioning, and not without irony, that Randy Udall inadvertently became part of Mitchell's Wind River narrative many years after writing his *Audubon* article about Mitchell's life and times. Early in his 1986 article, Udall mentions the many epigrams that Mitchell sprinkled throughout *Wind River Trails*, singling out this one for deeper, more skeptical consideration: "We don't stop hiking because we grow old, we grow old because we stop hiking."

This line caught my eye too. Like the others, it falls short of Confucius-level contemplation, and despite its poetic chiasmus, it is (unfortunately) not even close to being true. Udall was quick to point this out when he wrote of his meeting with Mitchell, who was then already halfway through his eighties.

"Sadly, Finis has begun to disprove that one," Udall lamented. "Although he has never stopped hiking, he has grown old. He carries his years, we carry his pack. Moving slowly, head bowed forward, Finis swings his walking sticks as if they were ski poles. Knowing that he used to walk forty miles in a day, one might pity this hobbling man, except that his presence, his being here at all, seems so noble."

Time stalks us all, but it had an extra hard time catching Finis Mitchell, who refused to quit hiking the Winds for an additional two years. Only then, at age eighty-seven, did he repudiate his decades-old aphorism by stubbornly

conceding that he really had grown too old to hike. And even after he quit, he didn't pass away until 1995, one day shy of his ninety-fourth birthday.

Eighteen years later, Udall proved Mitchell wrong once and for all. In June 2013, while hiking alone in the Wind Rivers on his way to Titcomb Basin, Udall collapsed and died of a preexisting health condition. He was sixty-one. Searchers found his body on an off-trail route at an elevation of 10,700 feet. Udall was lying on his side, hiking sticks still in his hands.

The grand sweep of Finis Mitchell's journey notwithstanding, it seems incredible from today's conservation perspective that any government agency would allow a partially employed and mostly uneducated former railroad worker to dump milk cans full of nonnative trout into otherwise pristine wilderness lakes. In the eight years Mitchell ran his fishing camp, he claimed to have stocked more than three hundred lakes with 2.5 million trout. That's 2.5 million individual trout, hundreds of thousands of which would mature to form self-sustaining, spawning populations, doubling and tripling in numbers and size within a few years. This is to say nothing of the thousands more lakes and streams that were passively stocked during the ensuing decades by virtue of connective hydrology.

Confronted with these stupefying figures, one wonders why Mitchell is considered a regional legend instead of an environmental terrorist. If I were to release even a handful of brook trout into a Wyoming trout stream today, I'd be thrown in jail—if the cops could reach me before I was beaten to death by local fly anglers.

After Mitchell's heyday, fish stocking in the Wind Rivers was gradually restricted, first to select sport species and then native species; finally, in the 1990s, fish stocking in the Winds was halted altogether—no tanker trucks, no airplane drops and certainly no more milk cans on horseback.

In fairness, Mitchell's haphazard stocking was not unusual for that era. Just as wild prairies were once valued more for their potential as cropland, each lake and river was likewise viewed as a potential farm—hence the term "planted" fish. Government agencies and citizen anglers alike classified any waterway without sport fish as "virgin," like a nubile woman awaiting impregnation. Nor was Mitchell the first to undertake stocking in western Wyoming; many foothill streams in the Winds were already stocked with nonnative fish species in the 1880s. By the time Mitchell was born, brown trout had been in the Americas for almost twenty years, brought from Germany by way of Michigan and New York.

"Everyone seemed to want big trout," Mitchell confessed, almost as though the question of stocking or not stocking was out of his hands. In his

view, and that of the Wyoming Board of Fish commissioners, he was guilty of nothing more than meeting the demands of his customers and improving the countryside for those who would come after him.

That's why it's unproductive and unfair to characterize Mitchell's legacy as either legend or crime—it must necessarily be both and neither, depending on the point in time from which you consider it. Mitchell isn't around to stand trial for his actions, but they were not considered criminal when he was. And he would not be considered a legend today for doing what he did, but then again, nobody would even attempt doing anything like that nowadays.

In his article "These Waters Were All Virgin," historian Jeffery Nichols provides an excellently nuanced evaluation of what Mitchell's efforts meant to Wyoming, the Bridger Wilderness, and the Wind Rivers. "In one important way," wrote Nichols, "the Winds do not seem to fit the famous definition of 'wilderness' written into the Wilderness Act, which reads in part: 'An area where the earth and its community of life are untrammeled by man.'"

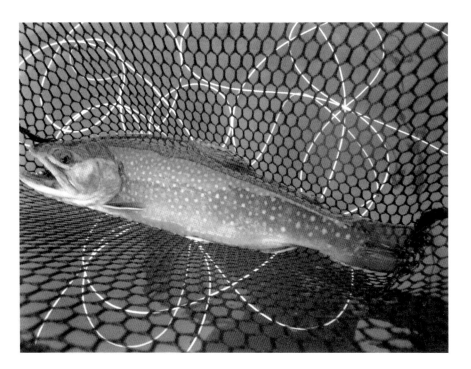

If I were to release even a handful of brook trout into a Wyoming trout stream today, I'd be thrown in jail—if the cops could reach me before I was beaten to death by local fly anglers. *Photo by Chadd VanZanten.*

It's true that environmental historians have vacated the notion that the natural world was suspended in some static, primeval state before the arrival of modern humans. Nature changes constantly, regardless of the presence or absence of people, so designations like "pristine" and "wilderness" will always be arbitrary constructs. But surely this situation is unique for its scale and scope: millions of fish released and hundreds of waterways abruptly and drastically transformed after thousands of years of natural isolation.

And although Mitchell began his exuberant stocking program long before the federal definition and designation of wilderness were created, his actions nevertheless gave rise to a paradox: massive populations of trout that are nonnative but wild, as well as a fishery that sustains itself and therefore seems utterly natural but is largely the result of wholesale human intervention. This is the conundrum of experiencing any designated wilderness: one must either deliberately disregard its environmental history or never dig it up in the first place. The only thing that makes the case of the Wind Rivers unique is that the denial or ignorance called for borders on absurd.

It's said that Mitchell himself had misgivings later in his life about the severe impacts of his project and that he questioned the wisdom of stocking so many fish without greater forethought. Brook trout in particular are problematic in wild waterways that might otherwise belong to cutthroat trout—they effortlessly outbreed and overrun cutthroats. Today in Big Sandy Lake, where Mitchell caught his first seventeen transplanted cutthroat trout, there doesn't seem to be a single cutt. Klaus and I have spent many days fishing there and have never once caught a cutthroat, witnessed one caught or even seen one in the water. The vast, sandy-floored lake now is completely full of brook trout, and while I've hooked a few two-pounders there, the rest have been small—twelve inches and under.

Mitchell made himself an inseparable part of the Winds, and it sometimes seems like that may have been his aim all along. Even within the pages of his self-published guidebook, Mitchell and his aphorisms are often too present, too central. The hiking directions and fishing advice are as generous and useful as they can be, but between every line you see Mitchell, his toe conspicuously in the sand. It's obvious that he wanted everyone to visit the Winds, but he seems almost as anxious for everyone to know that he'd gotten there first, stocked the place with fish and that he was the Lord of the Winds, a nickname that is to me just as anachronistically distasteful as Mitchell's fish stocking practices. Few people claim the title of "lord" unless also claiming lord*ship*—it doesn't seem like a nickname at all, but an appellation that a cynic might suspect was self-assigned, or at least too eagerly adopted.

There are, obviously, no plans or even vocal proponents for reverting the Wind Rivers fishery to its pre-Finis condition. Not even an act of Congress could do that, and it would take another hundred years to accomplish anyway. Nichols rightly stated that the prevailing attitude toward the fish of the Wind Rivers is "What is done is done."

And he continues:

> *The consensus on Wind River trout has been a useful one: it helped Finis burnish his credentials as a conservationist, it helped wilderness advocates garner support for statutory protection, and it served to promote Wyoming fishing and tourism....From an early age, Finis took much-needed food from the Winds to supplement his family's marginal farming, like millions of other Americans. At another desperate time, he manipulated the ecosystems of mountain lakes to make them provide him a livelihood and recreation for those to come, as many others had done in other waters. But throughout his life, the Winds also meant beauty, spiritual solace, and recreation.*

It seems that if we can learn something from what Finis Mitchell did, regardless of what it is, that will have to be enough.

I remember fishing with Klaus one summer in the Winds. We'd found a river high in the drainage where Mitchell first stocked his milk-can fingerlings. We'd been at it for less than an hour and were doing quite well, catching nice cutthroats and rainbows with that regularity that verges on embarrassing, when from around a bend in the stream Klaus announced that he'd hooked "a really big one." I never got a look at that fish, but in the ensuing excitement, the top section of Klaus's underpowered 4-weight broke. I slogged upstream to where he stood crestfallen in the flow, holding the broken rod.

"Well," I said, assessing the break, "what was it?"

"Cutty," he said without equivocation. He held up his index fingers to approximate its size.

"How'd you know?"

"The spots." I nodded.

We sat on the streambank and pondered how to fix the rod. I tried inserting a peg of whittled willow into the break and wrapping it with 6x tippet, but without tools or glue, it was pointless. Instead, we stuck together and took turns fishing with my rod, taking turns and playing what J.R. Hartley called the game of "Alternates." At the end of the day, we'd caught close to one hundred fish that way, many of which were fifteen

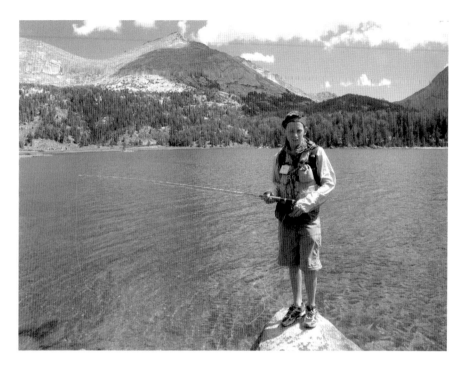

There is sometimes nothing you can say about a fishing trip to improve its quality in your memory, and in those cases, it is usually best not to try. *Photo by Chadd VanZanten.*

inches and longer. Beautiful and wild despite their antecedents, they were fish captured one sunny day among the batholithic granite grandeur of the Wind River Range.

Klaus and I don't talk much about that trip. Whenever the topic comes up, we can only grin and shake our heads. There is sometimes nothing you can say about a fishing trip to improve its quality in your memory, and in those cases, it is best not to try. But I know that no matter where we are or how we change, Klaus and I will always be connected by a fish of the Wind Rivers—a fish that broke a fly rod. It was a fish I never saw, one that may or may not have been "really big" but was identified to my satisfaction as a cutthroat.

I have tried many times—on paper and in my own mind—to explain how this connection works, and although I may scoff at Finis Mitchell's heavy-handed attempts at backcountry dialectics, my own results seem even less enlightening.

Photos by Klaus VanZanten.

Photos by Klaus VanZanten.

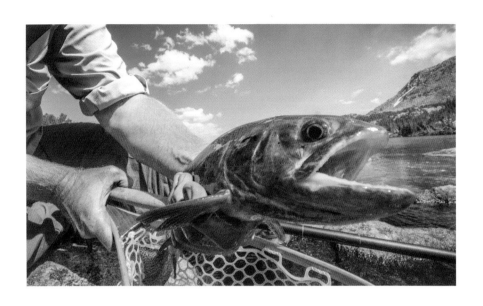

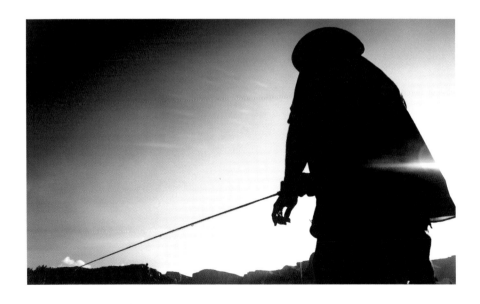

Photos by Klaus VanZanten.

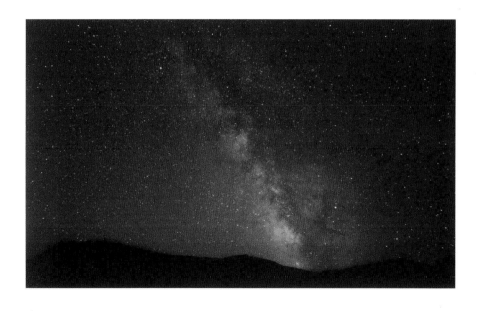

Photos by Klaus VanZanten.

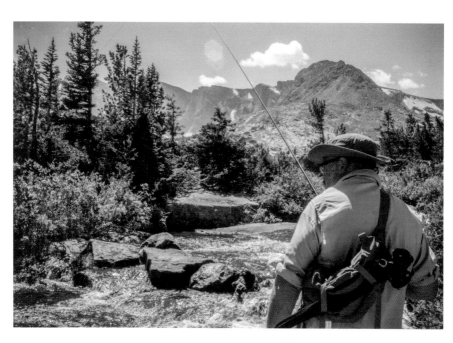

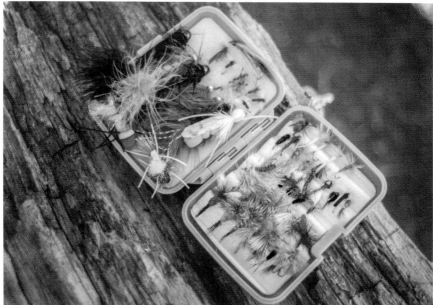

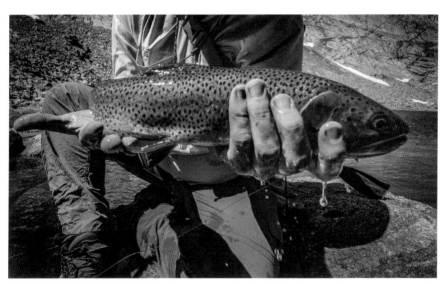

Photos by Klaus VanZanten.

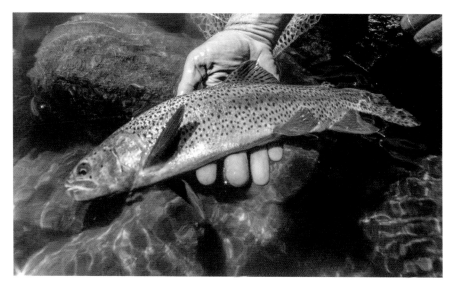

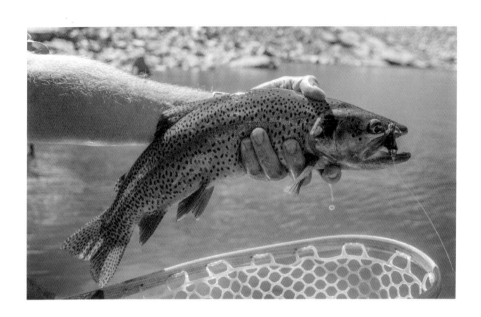

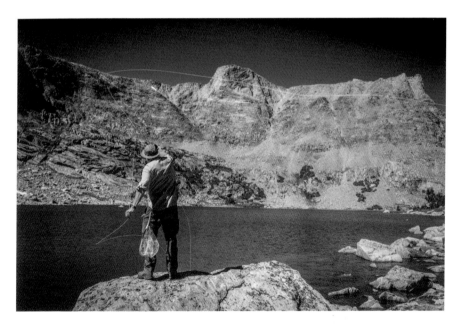

Photos by Klaus VanZanten.

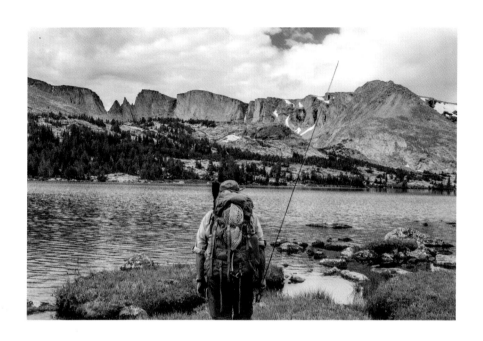

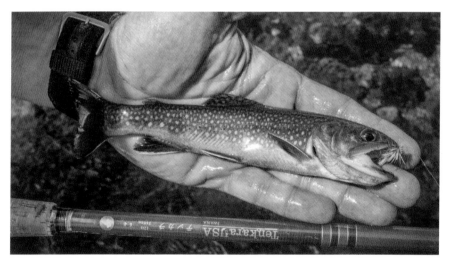

Photos by Klaus VanZanten.

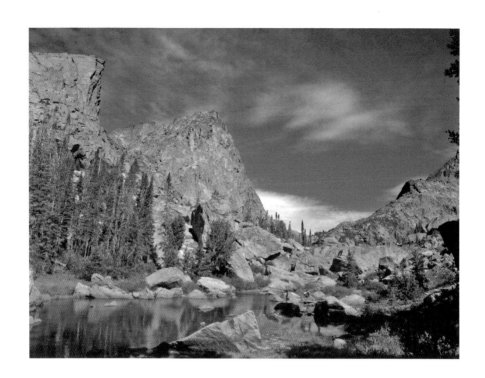

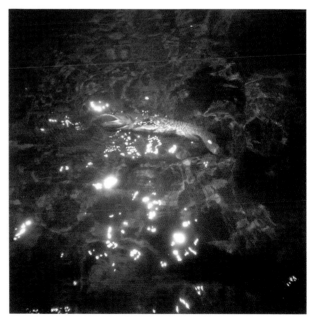

Above: Photo by Chadd VanZanten.

Right: Photo by Brian L. Schiele.

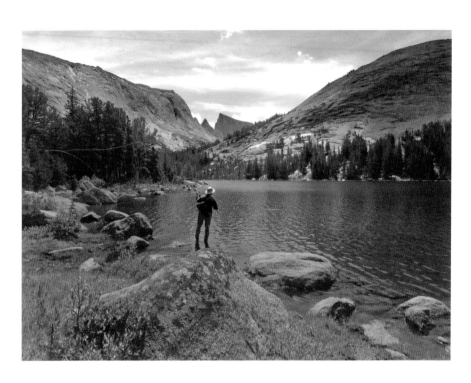

Photos by Chadd VanZanten.

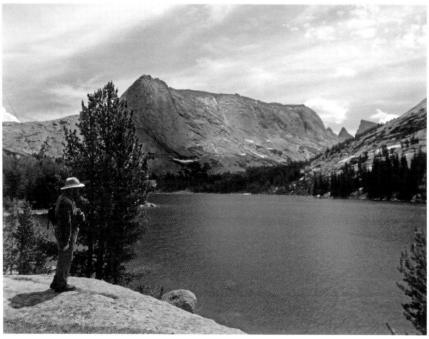

Photos by Chadd VanZanten.

All I can say is that I owe that connection and that day to a guy who fecklessly planted fish that spawned more fish, which moved upstream and down to spawn more. Finis Mitchell's motives were his own, and they usually had to do with nothing more than self-preservation. This makes it difficult to critique his legacy, but that day I spent with Klaus came out of milk cans covered with burlap, sent into the mountains by commissioners of fish conservation and then lashed to the side of packhorses borrowed from local ranchers almost a century ago.

Finis Mitchell gave us that day.

GOODBYE TO AIRPLANES

It's a farewell.

To backpack into the wilderness of the Wind River Range is to say farewell to smartphones and headphones. It's a wave goodbye to cold beer and hot showers. I explained this to the gentleman berry farmer who came with me one year. He'd never been to the backcountry, and he asked me for a packing list.

"There's no list," I answered. "If you really need it, I'll make you one, but it'll be a list of what to leave at home. You bring things that you'll die if you don't have. That's the list." The rest you say goodbye to. Goodbye, hand soap. Goodbye, Dr. Pepper. Goodbye, clean underwear. I told the berry farmer that this is not bad news. So many of those sacrifices are also on the list of annoyances that we are happy to get away from: e-mail, fluorescent lights, the human race.

"You know, after catching all these fish, it'll be really nice to sit in some traffic."

"Yeah. I'm gonna go straight to Walmart. Stand in a long line. Buy a goddamn eight-pack of canned air. Maybe some tube socks." Nobody says stuff like that. So, it's a wave goodbye and maybe the middle finger.

There are things that some people will miss but others won't, or things you maybe should miss but don't. Like air conditioning, junk food, a date with your girl.

The berry farmer wasn't fond of sleeping on the ground, but he seemed okay with becoming progressively filthier, and he never complained about

shitting in the open air. Personally, I prefer the civilized reassurance of a big American commode beneath me as opposed to teetering over a hole in the ground, taking aim like some drunken bombardier at his bombsite.

But there is one thing that you can never say goodbye to, regardless of how far you hike in. No matter how long you stay out or how dirty you get, there will always be at least one reminder that you are a native of today's small, tightly networked world.

You can never say goodbye to the airplanes.

Sometimes it's just the thunderous grumble of unseen jet engines. Or it's the livid incision of a contrail that hangs in the air for an hour. Either way, the airplanes are always up there. You can't get away from them. And although their noise might disturb the quiet of a rare, windless evening, and their crisscrossed trails might leave an enormous white X in the photo of the best fish of the day, I never thoroughly object to the airplanes.

Maybe it's because airplanes are a reassurance that civilization is still there—like when I was a kid camping in the backyard and I'd see my mom through the kitchen window. The airplanes say, "Don't worry. Cheeseburgers and Dr. Pepper will be here when you get back."

In terms of straight-line measurement, as the crow flies, we were only 158 miles from home, and even if you measured in miles actually traveled along roads and trails, we'd come only 350. *Photo by Klaus VanZanten.*

They remind you of the inverse, too, that despite civilization's reach, there are still places you can get to only on foot. The airplanes remind us that motion is not necessarily movement, that you can travel very far without actually going anywhere.

For instance, if you want to fly to New York City, you need a few hours to brush your teeth, pack and drive to the airport. Even if you're pre-screened (which you're not), you'll spend another hour parking, checking luggage and clearing TSA. Assuming the flight's on time (which it won't be), you'll sit for another thirty minutes while those with window seats watch the baggage handlers treat the luggage with great cruelty. Then it's five hours in the air, and that's if the flight is nonstop (which it's not).

So, even if you didn't have to start really early in the morning (which you did), it's still twelve hours of hustling and flying, and then there's that nauseating little shuttle ride into the city, which is another forty-five minutes—and that's if there's no traffic (and there's never no traffic).

Then you go to a show or a museum. Or you eat a lobster in the basement of Grand Central Terminal, and after that, you tell yourself that you've enjoyed something finer, that you've made a great voyage. But it's not convincing, because in reality you're sort of back where you started—under a roof, in front of a mirror, brushing your teeth.

Plus, you're tired.

"Look at that," says a weary air traveler as he sips half a can of Diet Pepsi in a plastic cup, breathing in the endlessly recirculated farts of the other passengers. He looks down at the upthrust, convoluted landscape of the Rocky Mountains and says, "So desolate." On the ground, a backcountry angler releases a peerless wild trout, glances up at the airplane and mutters exactly the same thing. From the bank of a remote mountain stream, your perspective is different.

If I want to hike into the Wind Rivers, there's still lots of traveling—a day of driving along Wyoming state highways whose surface conditions range from "somewhat adequately maintained" to "we are working on it." Then the travel continues on unpaved roads that range from "poorly maintained" to "apparently forsaken." Only after miles of kidney-busting washboards and maybe several wrong turns does the real trip even start. The long drive is the easy part.

I shrug into the harness of my pack and feel its weight on my shoulders and hips. I've forgotten something, I know I have. I don't know what yet, but I always forget something and I've always got something that I don't really need. But it's too late to fuss about that now—the pine needle duff

is crunching underfoot, and there is wind moving in the treetops. Time to start walking.

There may be a few more wrong turns on the trail, but at the end of the day, I'm building a deadfall campfire. The towering granite cliff face on the other side of the valley catches the final violet rays of sundown like some massive expanse of camera film. Plus, I'm tired. But it's the good kind of tired.

When it's night, the stars are so immensely dense there is nearly no blackness to separate them. To look at them is to see into the past, their light so delayed by cosmic distance. Stare at them long enough, and you can realize a time when there were no roads or cars—just natives and fur trappers. Look a little longer and the glaciers that scooped out the cirques reappear, along with woolly mammoths and Stone Age hunting parties.

I'm sure you know better than to be overly impressed by all of this. Despite the solitude and surplus splendor, a trip to the Wind Rivers is still mostly just a bunch of office workers and city people camping, and we tenderfoots noisily insist that outdoor gear manufacturers make things as easy as possible for us. And they oblige, designing hiking boots so ruthlessly engineered for comfort you don't really have to break them in anymore. It seems like a cheat. They made me a sleeping bag that rolls down to the size of a loaf of bread and weighs only a little more than a party-sized sack of Doritos, and I still complain about how heavy my pack is.

Then, in a weird and vicious cycle, the pack-weight savings permit us to defeat the purpose of the trip by bringing along extras that remind us of how difficult it is to truly depart from civilization to begin with—smartphones, playing cards, solar-powered chargers.

The night before our hike, the berry farmer upended his pack onto the bed of my hotel room. His way of asking for advice. There on the bed lay unnecessaries of all kinds—cook pots, spare clothing, a folding shovel. Among his rations was a package of precooked bacon and two big packs of Red Vines. I insisted that he jettison the shovel and Red Vines. The bacon he wouldn't part with.

The berry farmer also brought his smartphone, ostensibly because it was the best camera he owned. I'd have tried to talk him out of that, too, but I didn't know he had it until we'd topped a pass that stood at an elevation of nearly eleven thousand feet, which placed the hazy Wyoming horizon one hundred miles or more in the distance. As we rested and took our photos, the berry farmer noticed that his phone was getting reception, so he called his wife.

Photo by Klaus VanZanten.

"Heya, hon," he droned. "We're just up here taking a break and I saw that my phone had bars, so, I thought I'd call ya." He didn't notice my lugubrious display of eye-rolling. I was freshly and happily divorced at the time and was in no danger of making or receiving any such call.

"Oh, yeah," he admitted as he shrugged and nodded at the view. "It's real beautiful."

Divorced or married, you'd never catch me with a phone in the backcountry—because I can't be trusted. I'd make a bunch of calls, post a selfie, maybe order some canned air. So, it's not my place to scorn those who want to stay tethered. What bothered me was the berry farmer's tone of voice. It was like he didn't realize he was in the wilderness at all but just down at the supermarket, checking to see if he should pick up some apples or batteries. As though he had no idea that if he suddenly dropped dead out there, it might be a few days before anyone could get his remains even down to Lander, and a few days more to get him back to his berry farm for a proper burial.

He said, "Hon, I'll have to take care of that when I get back." The speaker in the phone was loud enough for me to hear his wife's end of the conversation, and she'd reminded him about some appliance in their house that was making a funny sound. The water heater or dishwasher. The berry

farmer was supposed to have addressed this already, so now his wife wanted to know what to do if it stopped working before he returned.

"I don't know," he complained. "Look in the phonebook."

She did not like that idea.

"You could call my dad," he sighed. "But it's not gonna break, so don't worry."

I sat down and leaned into my pack, folding my arms over my chest as the berry farmer made a series of promises about the things he'd do when he got back.

"You are back," I thought. "You're still down there."

The call went on for a few minutes, and maybe it wasn't just his tone of voice that annoyed me. The berry farmer had torn open a portal to the place we were trying to get away from. The contrails and jet sounds? Those are inescapable. But a cellphone conversation about a broken dishwasher was a choice, one that chased away the mammoths and returned us to where we'd started—I might as well be back at my bathroom sink again.

To understand why a thing like that might have any effect at all on the trip, you have remember that out there, it's not about distance. Distance means almost nothing. In terms of straight-line measurement, as the crow flies, we were only 158 miles from home, and even if you measured in miles actually traveled along roads and trails, we'd come only 350.

You can escape using distance, by putting miles between yourself and your office, and sometimes the only way to do that is by getting on an airplane. But long distances and the places they take you are often just a cruel prank, like a trip to Manhattan, where your destination and endpoint are only slightly different versions of the same place.

Fortunately, there's a loophole. It's always been there, but Albert Einstein put a name to it, and he called it "relativity." It says that time and distance are essentially interchangeable, and if interchangeable, then equivalent. The stars in the sky are very far away both in terms of time and distance, but you choose which one you see. In other words, you can use time in place of distance if that suits you better. Studying maps, tying flies, packing gear—technically, you can count all of that as distance. Now you can really get somewhere.

Fly eight hours from your house in any direction and you can easily de-plane in almost exactly the same place, but walk eight hours into the backcountry, even though it may be only twelve miles, and it's like passing into another dimension. If the berry farmer understood any of this, it was strictly subconsciously.

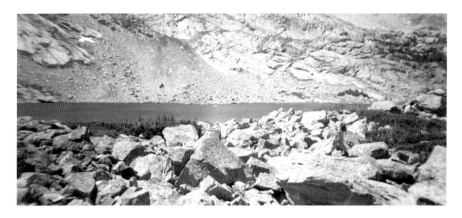

Photo by Brian L. Schiele.

"I apologize for that," he confessed when at last he dropped the phone into his shirt pocket and re-shouldered his pack.

"No, I get it," I said as we took to the trail. "It's hard to break away. That's why I leave mine back there."

A day later, when the berry farmer and I reached the high, glacially fed lake that was our ultimate destination, he understood a little better. Then he saw the muscular, piscivorous rainbow trout that patrol the boulder-strewn edge of the water and things became clearer still.

I passed him a big gaudy fly with a foam body and spun hair for a head. "Throw that out there," I told him. "Put it in front of one of these big cruisers."

He scowled at the fly. "What is this?"

"Dave's Hopper. Smack it down on the water as hard as you can."

A big rainbow came in from our left, gliding just beneath the surface, paralleling the lakeshore. The berry farmer started casting, fighting the wind. His line shot out too short to intercept the trout, but the fly splashed down like a tiny recovery capsule fallen from space, and the hard wind blew a little spindrift. We watched as the fish made a tight starboard turn and showed us the interior of his whole mouth as he confidently whelmed the fly.

The berry farmer understood clearly then: there is no goodbye to the airplanes, but everything else is negotiable. You can walk away from almost all of it. And when you do, you'll know how it was for Einstein and those primitive hunters. When you tell yourself that you've enjoyed something finer, that you've made some great voyage, you will be more inclined believe it.

FINAL PLAN F

The original plan was for the four of us to backpack into the Wind Rivers and fish for four days—me, my son Klaus, my buddy Brad and Brad's buddy Chris. Four of us for four days. That was the plan.

The four-man fishing trip has a certain elegance. Four people can furnish good company without stepping on one another's feet. A four-man team also fits perfectly into one SUV, so you can split gas money. And if you encounter a bear, odds are decent it will eat one of your friends instead of you. The four-man team is simple, efficient.

But plans fall apart. It's what they do. This one crumbled when another of Brad's buddies asked to join us, and Brad obliged. I don't even remember the guy's name. But because we could no longer fit in one vehicle, we split into two teams, with each group driving separately. This was Plan B.

Nobody panicked. Two teams in separate vehicles actually adds flexibility to a trip like this. For example, it enables part of the group to leave early or stay longer. Having two vehicles instead of one is also more convenient in the event that one of the two drivers is devoured by a bear. You might say that our back-up plan was marginally better than the original. But back-up plans fall apart, too.

Chris needed to move the trip up one day because of his work schedule, but I couldn't go any earlier because of mine, so we created Plan C—the two teams would drive up on consecutive days and fish together during the two-day overlap. Not ideal, but not tragic as far as back-up back-up plans go. However, we soon moved on to Plan D when Klaus had to cancel altogether

because of summer swim team practice. Plan D survived only briefly before Plan E was hatched so that Brad could leave an additional day early for reasons I've forgotten.

According to Plan E, I would leave home on Sunday, hike in alone on Monday and meet up with Brad's team that afternoon. Unfortunately, I was delayed by one extra day because of a minor case of engine trouble, but it's meaningless to keep track of the back-up plans from here on, because by then Brad was in the mountains and we couldn't communicate with anything less than satellite phones, and we had no satellite phones.

Under the terms of what I will designate "Final Plan F," I hiked in a day and a half late with the intention of somehow finding Brad, but Brad's team was meanwhile plagued by a variety of hardships, including heavy, constant rain and a case of violent diarrhea for the guy whose name I can't remember, which caused them to hike out after only three days, which meant we missed one another completely.

I wasn't heartbroken.

The original plan of teamwork and company lay in utter shambles, but I was actually okay with this. I love fishing alone, and I had an entire week off. Final Plan F allowed me to fish alone and stay as long as my food held out, and I figured I could force it to hold out for a long time. I was actually fairly excited about it. That didn't last.

Brad told me later that it rained day and night during his trip. It was still raining a little on my first day, but as soon as it cleared up, I grabbed my fly rod and fished a nearby lake, where the exuberance of the resident

I'd always assumed I could safely solo if I wanted to. However, between my sons and friends, the opportunity had never presented itself. *Photo by Brian L. Schiele.*

brook trout is surpassed only by their sheer numbers. With no traveling companions to answer to, I realized I could fish for the rest of the day if I wanted to. So I did.

Back at my campsite, I pulled on a jacket against the evening chill, and then I unpacked my foodstuffs. The lack of dinnertime banter was a bit discouraging, but I told myself this could also pass for tranquility. For dinner, I had a custom-made dehydrated casserole of potatoes, bacon and veggies. I'd used the recipe several times before, and although the pre-packed ingredients required only the addition of boiling water, I figured I must have committed some major error in its preparation because the first mouthful was only slightly more appetizing than boiled pocket lint.

As I choked it down, I made an important discovery about subsisting in the wilderness: having company really helps you lie to yourself about how the food tastes. When you're with a buddy, even if the food is crummy, you say, "You know, this doesn't taste too bad." And he agrees—"Yeah, the crumbled bacon was a great idea." Without companionship, every meal tastes exactly as good as it really is, which of course is usually somewhere in the vicinity of "not very."

No campfires were allowed in the Bridger Wilderness that year, and the short-lived flames of my cookstove made a poor substitute. Without fire or friend, I sat watching the night draw its black hood over my campsite, and I formed misgivings about my ability to pass a week in so lonesome a condition.

I'd seen solo backpackers before. I saw several on the hike in. Soloing never struck me as particularly demanding, but it's definitely not highly advisable and nowhere near as safe as traveling with others. Just look in the *Pinedale Roundup* or the *Sublette Examiner*, and you'll find many stories of hikers of all experience levels who went into the Bridger Wilderness by themselves and had to be found by search parties—or never came out at all. Falls, freak accidents and minor health problems that might be otherwise unworthy of mention can turn grave when you're that far from roads and phones.

I'd always assumed I could safely solo if I wanted to. However, between my sons and friends, the opportunity had never presented itself. In my tent that night, I thought a lot about my two boys and how great it would be to fish with them awhile instead of by myself for a week. I thought about how fun it was to fish with Brad. And I'd never even met Chris, but I thought quite a bit about him, too.

In the morning, the sun rose and warmed my tent, which got me looking on the bright side again. As I boiled water for cocoa and stood with my back

to the sunrise, I laid plans for a full day of solitary fishing. I identified an area to explore, and with my tenkara rod in hand, I soon discovered that the stream there held equal numbers of cutthroat and brook trout.

It was a noisy stream, with lots of riffles and rapids, so instead of the hair-and-feather flies I prefer, I tied on a gaudy, foam-bodied fly with rubber legs and a shiny foil wing. It was probably meant to be a salmonfly. Any actual insect would have regarded it as shamefully overdressed, but the cutts and brookies practically took turns at the fly, as though they might be under some kind of truce.

Most were small, twelve inches and down. However, as is usually the case in the Winds, by fishing with care and patience I was able to scare up a few larger fish, one of which was seventeen inches or thereabouts. But such good fortune is less satisfying when you're alone. A great fish is always greater when there's a witness to it.

With every fish I brought to hand, I checked the progress of the sun to ensure enough daylight remained for a few more casts. Hiking around in the dark in the Wind Rivers isn't exactly death-defying, but it's not to be taken lightly either.

To our primitive ancestors, night wasn't the respite it is to us. Today's man sees the setting sun as a signal to sit down and turn on the television. To our forebears, night was just another hazard to cope with, as threatening as any rival tribe or predator. When you are alone at night in a very remote place, you may not be gripped with the same fear felt by ancient man, but you'll get a taste of it—and I got mine that evening. As I hiked back to camp, I saw the face and forepaws of a large mammal emerging suddenly from the brush a few yards ahead. I knew instantly that it was a bear, and I resigned myself to a place on the front page of those small-town newspapers and their forensic retelling of my valiant but ultimately unsuccessful struggle for survival against one of the only North American apex predators that is not afraid of man. I'm still not sure how I avoided dropping everything and running like a scared cat.

However, in the faltering light, I eventually identified the creature as a really big porcupine, a very distant cousin to any animal that could do me harm. Even so, I stood frozen on the trail as it shambled away murmuring.

And so, a second day of solitary fishing was followed by a second evening of gloomy stillness, and the third day and evening passed in the same way. There was again no fire and no one to watch fire with, so I turned in shortly after dark. I'd hardly made a dent in my rations, but I realized I couldn't last the rest of the week no matter how many Clif Bars I had remaining. Before

I'd gotten all the way into my sleeping bag, I'd decided to abandon Final Plan F in favor of just heading home. I lay there for a long time, staring at the top vent of my tent where a little starlight leaked in.

My single most un-favorite thing about backpacking is breaking down my tent and packing away my gear, so in the morning, I stayed in bed and slept late. The birds sang a riot and the sun warmed the tent. I burrowed deeper into the down sleeping bag and slept on.

Then voices woke me up. People voices. I hurriedly unzipped the tent fly, poked my head out and squinted. There were four of them, coming up single file from the main trail by the lake. It was a guy about my age leading two teenagers, with an older guy bringing up the rear. They laughed and joked as they approached. Each carried a fishing rod, and although unannounced social calls are generally unheard of in the backcountry, I got it in my head that they were coming to visit me for some reason, so I hastily dressed myself.

They weren't coming to visit, of course. There was a footpath that wound past my campsite and went on to a smaller lake a mile or so up into the hills. But still I made it out of the tent and was sitting on the ground tying up my boots when they passed by.

"Hello," called the guy in the lead. "Nice morning, huh?"

I'd been trying so hard to pretend like I'd only just noticed them, I inadvertently answered, "Good!" In my defense, I'll point out that I hadn't spoken much in the previous seventy-two hours. I'd said hi to a few hikers on the trail the first day, and I think I said, "Good as it gets" the next day when a college kid asked me how the fishing had been.

"I mean, good morning," I stammered.

The lead guy chuckled and nodded.

"Going up to Blue Lake?" I asked before they got out of earshot.

They didn't want to stop and talk, I could see that, but the lead guy slowed down a little.

"Yep," he said over his shoulder. "Ever been up there?"

"Sure, yeah," I said. "The fishing's great."

That stopped them.

"How great?"

"Yeah, and how far is it?" asked the older guy.

I looked up the hill and pursed my lips. "Mile," I said. "But this trail doesn't really go all the way up. It's hard to follow once you get to the boulders, and it's kind of a climb. But the fishing?" I held up my hands. "Ridiculous."

They traded glances, nodding and grinning.

"What do you use up there?"

"What do you got?" I asked.

They came over and surrendered their tackle for inspection. Apparently, they were visiting after all. The younger guy and his son were fly anglers. The older guy and the other boy had spin gear.

"These spinners will work," I said, pointing. "Jigs'll work. Got any streamers? Good. Definitely use those. And just about any of these big dries will catch something. They climb all over these."

"What's up there? Browns?"

"Brookies."

The older guy was sweating a little already. "Is it hard to find?"

"Not really, but you might want to go up the ravine instead. It's a longer hike, but you can follow the creek right to the lake."

"How much longer?"

"Mile and a half, maybe. It's tricky. It's boulders all the way up."

"Hm."

"Just go slow," I said. "You'll be fine. If I can make it, you can."

They pocketed up their boxes and thanked me.

"I'm Dennis," said the lead guy. He introduced the others. Tanner, Jay and the older fellow was Boyd. We shook hands.

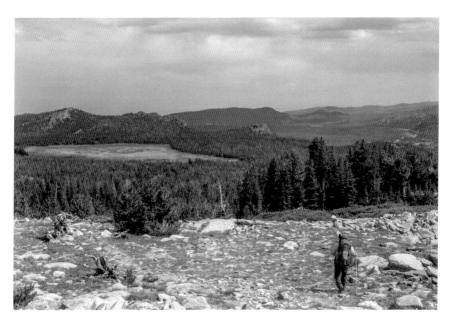

Photo by Klaus VanZanten.

"So," said Dennis, "you heading up there today? Want to come with us?"

"Thanks," I said, "but no. I'm heading home after breakfast."

"You by yourself?" he asked, looking around for other tents.

"Yep," I said. I may have put my hands on my hips and stood a little taller. They nodded, raised their eyebrows.

"You don't get nervous up here alone?" asked Boyd.

"Nope," I answered—a little too quickly.

"Well, we'll be up there all day if you change your mind."

They thanked me again, and I watched them file off up the ravine.

I set up my stove and laid out some breakfast fixings, pausing now and again to scan the hillside and mark the probable progress of Dennis and his party. They seemed like a nice bunch of fellows. I replayed our conversation in my head, hoping I hadn't understated the difficulty of the climb or overstated the excellence of the fishing.

Sunlight burned away the dew, and a mist rose in the glare. All around me the valley lay quiet and smoking like some primordial landscape, with only my tent and meager gear to suggest otherwise. Down in the floor of the valley, the fish in the lake began their morning rise.

When I'd finished my cocoa and rinsed the cooking gear, I stood over my tent and considered pulling up the first aluminum stake. I may have even bent down to get started. But I didn't pull it. Instead, I packed a lunch, put on a hat and grabbed my fly rod.

Plans fall through all the time. It's what they do.

THE ELK

Shawn spotted the elk first. He didn't say anything or even point. He was sitting with the rest of us around the evening fire pit, where our foil-wrapped trout lay hissing on the coals. We were making campfire talk and winding down for the night when Shawn sat upright and eyed something just beyond the firelight. The rest of us looked that direction and saw the bull elk approaching.

"Check it out, check it out."

"Holy crap."

Our Wind Rivers camp that year was pitched near the top of a low rise overlooking a lake. Behind us rose a boulder-studded knoll and behind that the granite shoulders of the mountains themselves. In the dying daylight, the elk had made its way up from the lakeshore without attracting our attention. Now he came through our camp like he owned the place.

He did, of course.

The elk came on with an unhurried gait, head pitched slightly back, antlers swaying over the long ridge of his spine. We fell silent and watched. He proceeded to the base of the knoll, passing within five yards of us, close enough for me to get a whiff of his barnyard odor. But he made almost no sound, only the faintest crunch of earth under his hooves.

I'm no hunter, but the rack looked impressive to me, the angles and points all softened by a jacket of velvet. And I think the elk was old—bony-looking and shaggy—but that didn't show in the steady way he walked. What impressed me more was that the elk showed so little alarm. Our huge fire

fumed and snapped, our tents like curious neon mushrooms huddled beneath the spruce and bristlecones, and we'd spread our wet clothes to dry on the rocks after some rain earlier that day. Six pairs of forward-facing, carnivore eyes had locked on the elk, but although he kept a wary eye likewise fixed on us as he passed, he didn't change his course or speed.

Had he been herded in our direction by a hiker down the hill? Was he just instinctively aware of the many threats we did not pose? Or was it something else?

The sun was down, but the western skyline was still aglow, and the interplay of twilight and firelight lit the elk's coat with a delicate, spectral glimmer. It was as if the dusk had gathered itself into a physical form so that darkness could finally fall.

Response to the elk differed for each individual. Shawn's father, Joe, was a tall Mormon dairy farmer and was pushing sixty. He'd been backpacking in the Wind Rivers and High Uintah for a few decades. He and his teenage sons Shawn, Matt and Isaac were principled hunters, so I'd guess they evaluated the bull's weight and counted the tines on his antlers. Or maybe they narrowed their eyes and placed imaginary rifleshots along the elk's thorax to pierce the lungs and heart and bring him down as quickly and humanely as possible.

My son Shreve was ten or twelve at the time, and he responded as I expected—back straight, mouth open, trading a glance with me to verify what we were seeing. We don't hunt game in my family, so for Shreve this was an encounter with a wild animal he hadn't often seen at such close range.

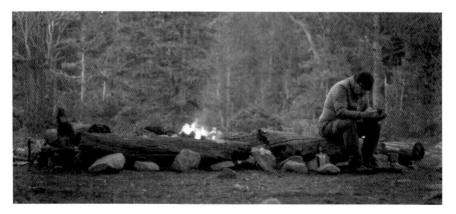

We were making campfire talk and winding down for the night when Shawn sat upright and eyed something just beyond the firelight. *Photo by Klaus VanZanten.*

I sat assessing the message in the elk's ascent. The way he strode so close, refusing to defer to the offense of our presence, wary indifference gleaming in his inky left eye. The Wind Rivers possesses a majesty that may nudge the sentimental mind toward reductive conclusions. Was this a visitation? A prefiguration?

When the elk reached the steeper grade of the knoll, he paused and swung his head around for a final look at us. Then he turned and bounded up, vaulting over the boulders and stunted spruce. The fluid, impassive power of his motion set the hairs on my arms on end. The elk continued his climb and was lost from view in the shadows. We stayed quiet for a minute, like the elk might come back.

He didn't, of course.

The conversation gradually resumed until we were laughing and poking at the coals again. But not Joe. When the elk was gone, Joe sat quietly, glancing back at the knoll with a sort of sleepy fondness. His face was crinkled in a smile, not like something was funny but like someone had done him a favor without being asked.

I considered Joe a backcountry mentor despite the fact that he didn't fly-fish. He also lacked high-end gear or catalogue hiking duds. Joe and his three boys instead relied on off-brand equipment, which was repaired here and there with duct tape. They backpacked in Wranglers and running shoes, eliciting dismissive sniffs from the Patagonia-clad through-hikers we'd meet. Instead of ultra-light, one-man tents, Joe and his sons packed different pieces of some old three-man tent they'd probably picked up cheap at a department store. Every night they crammed inside it to sleep, and every morning they argued about who'd snored and farted the most.

The one item of authentic backpacking gear Joe owned was a bashed-up old MSR stove and gas bottle. One year, it quit working midway through a trip. While the rest of us went fishing, Joe stayed in camp to fix it using a keychain multitool and bits of metal cannibalized from fishing lures. When we returned to camp, Joe was squinting in the evening's fading light, holding his mouth funny and straining to fit the fiddly bits together. With the stove reassembled, he pressurized the bottle, opened the valve and hit the striker. A ring of orange and blue flame erupted in the burner, and Joe grinned like he'd just been given the little stove as a gift. I have no doubt the unit is still serviceable now.

And so I sometimes chuckled at their camo ballcaps and jury-rigged gear, but I could never hold their rusticated ways against them. It was Joe and his sons who invited me on my first trip to the Winds, Joe who'd told me what to pack, Joe who'd showed me where to fish.

The morning after the elk came, we hiked up to an alpine valley and a lake surrounded by a lush peat bog. A long-ago glacier had left behind a collection of megaliths, which sat strewn around the lake like works of ancient, abstract art set around a reflecting pool.

Joe and his boys had been to the lake in years past, but they did not agree about whether the fishing there would be outrageous or deplorable. It was one or the other, depending on who you asked. Because it's almost impossible to visit the same area frequently, or for very long, fishing conditions in the Winds are difficult to ever predict or explain. The place is too remote, not to mention covered in snow for eight or nine months of the year, and so there is no good way to fish the same place several times a week throughout the year, no way to catalogue hatch times or hot spots over the course of a season. I figured Joe and his boys couldn't remember how it was at the lake because maybe the fishing had been hot one year but cold the next.

The matter was decided when we arrived and began fishing. It was the latter—very, very latter. I tried five flies of each variety in my stockpile but failed to incite a single rise. There was no cloud cover that morning, and the wind shifted constantly to the angle least favorable for casting. Very few of the fish were showing themselves, and most of them were out over the unreachable deeper water at the middle of the lake.

After a few hours, I tried a number 12 Griffith's Gnat and got a strike from a fish of some substance. He'd been feeding entirely under the mossy hummocks that overhung water's edge, so I hadn't seen him before I cast to him. Instead, I had to infer his presence by the rise rings he made, which appeared tellingly from beneath the peat every few feet along the springy, boggy bank. Who knows what he'd been eating up under there, but when I finally fine-tuned my side-arm cast and got the Griffith's to him, I had only a rise ring for a signal to set the hook.

The initial run was equal parts panic and fury, as is often the case with trout taken while loitering in what they suppose is impenetrable cover. He broke fast from his hideout and headed for deep water, leaving a series of softened Vs on the surface. Each pump of his tail raised a little vortex of the chartreuse sediment that lay at the bottom of the shallows.

I judged him to be an eighteen-inch cutthroat, a day-saving fish to be sure, especially if I could manage to get a good photo of him. That was the key—getting that photo. I know better now. Any fish, regardless of size, is a trophy if it's caught on a cast tricky enough to merit re-telling without much embellishment. And I would have to land him, but that turned out to be no problem because as the fish reached the incline leading to the deeps, he

called off the fight. He turned back toward shore, rolled onto one side and came straight to the net.

He wasn't a big fish. He had been earlier in the year, but now he was shortly post-spawn, weak and skinny. The few others I caught from that lake were the same—long but snaky, too hungry to resist a fly but too feeble to fight. I had to stay with each one until I was completely sure they revived, until my hands hurt from the cold water. I ended up feeling bad for messing with them at all.

I watched Shawn as he rigged up his spinning reel. A teenaged version of Joe, he was tall for his age with country-boy looks and his dad's aw-shucks grin. He was physically fit not by virtue of working out but by working outside. His dad had him choring on their farm just about every day, and when he wasn't working, he was hunting, fishing and hiking.

Shawn had his own way of fishing the lakes in the Wind Rivers. He'd climb a tall boulder near the bank, preferably higher than ten feet and with the wind at his back. From that elevation he'd heave a garish spinner in arcing casts across the water and then tow it back slow over the transition zone between the indigo depths and shallow coves. In this way, he and his brothers caught a few of the same snaky cutts.

Joe did not fish, that day or any other that I knew of. He preferred to find a seat on a rise or ledge and watch us fish—our solitary spectator. If there was a slope or log to recline against, he was happy for hours, looking down and shouting at us with unasked-for advice that we might not even clearly hear over the wind.

The hike up to the valley had been a far one, and the climb fairly steep. In the heat of the afternoon, as the fishing shut down altogether, we dispersed along the lake, eating trail mix and sunning on rocks. I tried to shrug off the disappointing fishing and admire the valley for its strange, treeless landscape—the peat gleaming like acres of neatly preened velveteen putting greens, the speckled gray granite monuments shining in the midday glare. By the time Joe whistled through his fingers to remind us that we still had to hike back to camp, the sun was already heading down.

The first part of the return hike was a rock-paved and steeply pitched trail that ran along the top of a ridge. It wasn't particularly perilous, but like so many places in the Winds, the elevation and high winds made it feel that way. We picked our way down the incline, our toes squashing into the tips of our boots.

Soon there were gray wet clouds boiling up. Thunder boomed so close that it reverberated in our lungs. Waves of heavy rain marched through,

which made the stones on the trail slippery, which made everything seem yet more treacherous.

Lightning started striking the ground as we reentered the treeline, and that's when we noticed that every third or fourth tree on the hillside was marked with lightning burns. Shawn and Matt went ahead of Joe and me. Soon they were out of our sight, and Shreve and Isaac were somewhere behind us. We were still more than an hour away from camp, we were exposed and the storm was mounting in strength.

"Let's stop here a minute," cried Joe from behind me.

"What for?" I asked, turning.

"Let's have a prayer."

"Now? Here? We're all spread out."

"Well, if this storm gets serious, we could get into trouble."

He shouted to Shawn and Matt. They couldn't hear him, though. They'd gone on too far. I looked behind us for Shreve and Isaac. Hopefully, they hadn't split off to take an overland shortcut back down to camp.

"Why not wait 'til we're down off this hill," I offered.

"No, let's stop here a minute. Matt! Shawn!"

I appreciated Joe's concern, but I had no faith in prayer. Not even a little. Furthermore, praying during a thunderstorm on that lightning-scorched hillside seemed to me like stopping on your way out of a burning house to call the fire department.

Joe yelled to his boys again, sighed heavily and then hustled ahead of me down the trail to find them, slipping and catching himself on the mud and rocks.

"Boys!" he hollered. "Let's stop a minute 'n pray!"

Shreve and Isaac came up behind me, and together we jogged carefully down to catch up with Joe. Now the route switched back and ran along the face of the mountain, which fell away steeply on one side. The rain collected in long muddy pools on the trail.

"Careful now," I said, more to myself than the boys.

At last we caught up to Joe and Shawn and Matt. But just as Joe opened his mouth to announce the purpose of our gathering, there came the stunning strobe of a close-by lightning bolt and, with it, an oppressive peal of thunder that I thought might flatten us. We ducked in unison, our hands flinching to our ears.

"Let's have a prayer," said Joe, voice raised against the resounding thunder. We shuffled without objections into a rough circle, removed our hats and bowed our heads.

Joe called on his god, front-loading the prayer with thanks for all the many blessings He had given us: our families and livelihood and health. Pausing

now and then for the thunder and wind, he gave thanks for Christ's mercy, His teachings, His foretold second coming. Like all agrarian Mormons, Joe gave thanks for the "moisture we've received," which I found slightly cheeky considering it was the rain he aimed to complain about. But he kept up the flattery, praising Heavenly Father for the excellence of His creation—to wit: the very mountain that we stood on.

I shifted from one foot to the other—I felt like this buttering-up stage was running a little long, but Joe turned at last to the subject of the storm and our safety, which he broached (quite shrewdly, I thought) in a "hey, speaking of mountains and rain" sort of way.

"If it be Thy will," said Joe, "we pray that Thou would calm this storm, that we'll b'able to travel in peace and safety."

Big rain droplets popped on our jackets and smacked our skulls. The storm was strengthening, but Joe evidently felt the occasion called for a few additional flourishes, so he reassured Heavenly Father that we all loved Him very much and that we would accept our fate if He left us at the mercy of the elements, but if anything could be done about the rain, it would help us out a lot and we would all be so grateful that we would commit to redoubling our efforts in His service.

I found it presumptuous of him to speak for the whole group without checking first, but in the interest of time, I didn't protest.

"These things we pray, in Jesus's name, amen."

To avoid the appearance of any disrespect, I held in place for a few reverent beats, but when I raised my head, I saw all four of our boys already twenty yards down the trail. Joe and I scurried after them, bracing against the gusting breeze and turning our faces away from the pelting rain. We threaded our way through the trees and the deluge, coming down a muddy switchback that gave onto a panoramic overlook of the valley below and the lake where we were camped.

All at once, the sun broke through the clouds like some blinding celestial hammer. The rain stopped and the thunderheads rolled back. Dazzling blue reflected from the lake below, and shafts of light and shadow radiated from the parting clouds, strongly suggesting that Christ's second coming really was just a few moments hence.

We slowed down. The sun roaming low shone on our faces and dried our clothes, as though consoling us for the rough go we'd had.

I don't remember if I spoke to Joe about what happened. I don't remember if anyone pointed out that he'd said a prayer to stop the rain and then the rain had stopped. Seems like someone would mention that, probably me.

Joe would never have taken credit for it, but I don't remember whether that conversation ever took place.

What I do remember is the expression on Joe's face as we hiked the rest of the way back to camp beneath the sunshine that he'd conjured. He was back to the smile he wore the night the elk came. Again he was lingering in that moment in a way the rest of us apparently couldn't or wouldn't—as though it were still unfolding. I was unconvinced about Joe's ability to command the elements, but maybe he had an even better superpower. Maybe there was something about his unaffected expeditions that enabled him to stretch out those backcountry moments like massive slabs of superheated glass. To Joe, the sudden presence of a wild animal in camp was not a fleeting footnote to an uneventful afternoon—it was a point in time where he could dwell. It began to appear that the sole purpose of his backpacking was to be open to such moments.

I lacked this ability entirely. The special events in my life—vacations, time with family and friends—seemed to end almost before they began. My every childhood memory of Christmas is a weirdly elongated period of jittery anticipation followed by post-holiday disenchantment. Sandwiched somewhere between is Christmas morning, blurring past like a dream or camera flash, something briefly vivid that left me squinting and blinking.

The harder you try to force something to be perfect, the harder it is to see when it already is. *Photo by Klaus VanZanten.*

Trips to the Winds—the same. Weeks of prep and packing followed by a dreary countdown of the days remaining. Then, afterward, evaluation of the trip and assignment of a letter grade based almost solely on the fish photos. Eventually, I would clean and stow my gear, and as the aromas of campsmoke and pinesap arose from the folds of my tent and clothes, I'd feel a stab of nostalgia for the eyeblink that was the trip, realizing finally that it was, in fact, over and that I'd paid close attention only to some paltry fraction of it. And in the end, all that remained was an urgent yearning to return.

Joe had no success criteria, didn't even bring a fishing rod, and if he packed a camera, it was the disposable kind with film inside. Joe had first brought his sons to the Winds when they were still too young to carry much gear, and he kept going back after he was too old to carry all of his own. But after all those years, he was only too happy to hump his heavy, off-brand pack into the backwoods, sleep for a week with his kids in a leaky, fart-smelling tent and justify the endeavor with nothing more thrilling than the view of a retreating storm or the slow passing-by of a bull elk at dusk.

And so I realized that the elk was not an apparition, and his coming was neither message nor presage.

It was a test.

Just as I evaluated and graded each trip and stream and fish, the Wind Rivers were likewise testing me. It was a test administered with the same indifference of the severe-faced proctors who'd watched over me in the cafeteria as I took the SATs back in high school, but this test consisted of only one question, repeated again and again: "What will you do with this moment?"

Joe passed the test without really trying, probably had never scored less than perfect in many years. I was just guessing at the answers. Was it the number of fish that mattered? The size? A compound of the two? Was it casting a dry to the perfect lie or a box of flies I'd tied myself?

Joe was the real messenger; me, I was filling in little blue Scantron circles at random.

That's why I always felt fidgety to go back. Not to "recharge" or "clear my head," as I would often romantically claim. It was an uptight drive to get the next trip right, to land that lurking leviathan, hoist him high for the one-hand hero shot or catch a backlit hatch and cast among it like some wag on a magazine. And the harder I tried to create the perfect trip, the more firmly I was told to study more carefully and come back next year to try again. Because even in the outstanding trip there is dissatisfaction—the gnawing hunch that it'll never get better than that, the bummer of a bigger

come-down. The harder you try to force something to be perfect, the harder it is to see when it already is.

When we packed up and took to the trail to head home that year, I ended up last in line, right behind Joe. After five days in the wilderness, we were ripe with body odor, and Joe worst of all. He smelled like livestock, like the old elk himself. When I came up too close or when the breeze shifted, I'd catch a blast of him in the face.

Unfortunately, there is in the canon of backpacking etiquette a somewhat-obscure directive that states when hiking a singletrack as a group, it's poor form to jump the line and go ahead of the person in front of you without some good reason. And so I kept protocol and trudged along behind Joe and his eye-blistering odor.

"You wanna go ahead a' me?" he asked over his shoulder. "I know I'm slow."

"Nah, you're fine."

I likely wouldn't have hiked any faster than Joe anyhow. His pack weighed probably ten pounds more than mine, and he had almost twenty years on me, but that didn't show in the steady way he walked.

As I struggled to find a distance that allowed me talk to Joe without smelling him, I tried to puzzle out his Zen, his power to stay put in a moment. When we were halfway back, we stepped off the trail for a snack, knees up and leaning into our packs like chairbacks.

"What is it about this place?" I asked him.

Joe shrugged and then grinned the humble grin that crinkled his face. "Probably something different for each person, don'tcha think?"

"Okay. So. For you."

"Hard to say," said Joe.

He thought about it for so long I had gotten ready to say something else to break the silence, but then he spoke up again. "We just get so caught up in things of the world. You know. Cars. Money. Clothes. Up here, none a' that makes a bit a' difference. Up here, it's just us. It's just time. Something like that. I don't know. I don't know how to put things." Joe was evidently more Buddhist than Mormon.

On the first day of camp, Joe would usually say something like, "We can go up Cirque a' Towers or we can go up Temple Lake." Then he'd wave his hand in the direction of each. "Or we can stay put. Don't make a bit a' difference t'me. We're up here. That's all I care about."

I took a few more trips with Joe, but he's since stopped backpacking. I never did piece together his particular flavor of Zen, but I've been working

Photo by Brian L. Schiele.

hard on my own. It's not finished. I still have to reread the test questions and double-check my answers.

Of all the people I've backpacked with in the Winds, Joe was most at home there, most at ease, and I know now it's because he didn't go to catch or climb anything. He wasn't interested in taking anything away—not even photos. There didn't seem to be anything specific he even wanted to look at.

Perilously close to freeing himself from the desire and longing that can so firmly hold us, Joe didn't care to see anything in particular because he had become content with practically everything in general.

Joe was indeed the visitor who does not remain, which does little to explain why I often expect to see him on the trail ahead of me each time I go back.

A PARTIAL LIST OF WHAT NOT TO BRING

YOUR BEST FLY ROD

Unless you have impeccable karma, leave your high-dollar rod at home when you pack for the Winds. Something happens when you hike into remote places with only what you can carry on your back. Fate gets involved. Not in a good way, but usually in a way that will teach you a stern lesson. Forget your rain jacket, for instance, and it will rain every day. If you rely on something as coarse and earthly as an heirloom fly rod to make your

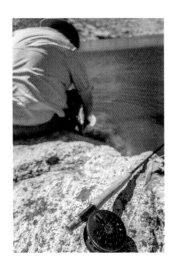

Bring the best rod you're okay with busting. *Photo by Klaus VanZanten.*

wilderness angling trip meaningful, Fate will not stand for it. Fate is a total prick, and he hates fly anglers. So if you pin your hopes to a photo of yourself posing with your priceless fly rod and the trophy trout you landed with it, you'll bust that rod, lose that trout and drop the camera over the falls. More likely, you'll stumble while pulling up your trousers after answering nature's call and step on the rod before you even get to the water.

YOUR WORST FLY ROD

Inversely, Fate will be displeased if you try smuggling shoddy equipment into the wilderness. Yes, you'll break the expensive vintage bamboo outfit if you bring that one, but if try to cheat Fate and pack in some old

junker, it'll do something worse than break—it'll let you down and then break later on. Bring your workhorse, a rod that casts well in a stiff wind and has a good replacement plan. Bring the best rod you're okay with busting.

WADERS

If you bring waders, you won't need them, and if you don't bring them, you'll wish you had. But even lightweight waders weigh several pounds, and wading boots are heavier still. When I backpack with waders, I use sandals instead of wading boots, which is not ideal for traction and ankle support, but the sandals weigh much less than boots and the sandals are handy for stream crossings and wet wading. If you do decide to bring your waders, designate them as Wind Rivers–only and don't use them in other watersheds, especially those known to have parasite or invasive problems like didymo algae (aka "rock snot") or whirling disease. Owing to its elevation, remoteness and the predominant trout species, the Winds are resistant to many threats that plague lower-elevation waterways, but I don't think you ever could be too careful.

BOOKS

I used to think that my wilderness experience might be enhanced by pastoral interludes of reading. One year I brought a copy of John Gierach's *Trout Bum* because in it he writes about fly-fishing in the high country, and I thought it'd be really, you know, like cultivated, to read while I myself was fly-fishing in the high country. But I didn't read much on that trip, which is to say I didn't even open the book once. I carried half a pound of printed paper up the mountain and then brought it back down. There is just too much else to do on a backpacking trip, such as gathering firewood, fetching water and cooking meals. The mere act of taking a shit takes about three times longer than it does at home. Then there's the little matter of fishing, which can be good at literally every hour of the day, including at night when you might be tempted to huddle in your tent and read by the light of a headlamp. Save your batteries. Look at the stars instead. Leave your books on their shelves, even the one you're holding now. Apologies to Mr. Gierach, but if you really need something to read up there, there's plenty of water for that.

HANG GLIDER

It is contrary to federal statute to operate a hang glider in designated wilderness areas. Signage posted along the trails on the wilderness borders is clear about this:

WILDERNESS AREA
Closed to motor vehicles,
motorized equipment,
hang gliders and bicycles
Violations Punishable

Quite clear and specific—of the many non-motorized vehicular contrivances that might be mentioned (skateboards, wheel barrows, kick scooters, rickshaws, baby strollers) only hang gliders and bicycles are singled out. So, by weirdly specific federal mandate, leave those hang gliders at home.

POOP SHOVEL

The issue of pooping in the backcountry is, well, urgent. The pun is grudgingly intended, but the urgency is real and it can't be, well, flushed away. According to a report by the Outdoor Foundation, more than 10 million Americans went backpacking in 2015, a number that has increased by about 1 million annually since the early 2000s. The Outdoor Foundation defines a backpacking trip as staying outside farther than one quarter mile from a vehicle for at least one night, so these statistics surely include campers who had access to campground amenities like flush toilets and vault latrines—and perhaps a few of those trips were simply epic benders. But even a conservative extrapolation suggests that Americans are relieving themselves out of doors by the millions. Considering that there are only a few million bears in all of North America, there are way more of us shitting in the woods than them.

Some recreational lands have pack-out-your-poop mandates (like Canyonlands in Utah and Mount Whitney in California), but most wilderness areas have blessedly few mandatory regulations. To keep it that way (at least until I get too old to hike), let's all do our dirty business with class and consideration, and that means dig-and-bury. It's not difficult. Step 1: Find a site about two hundred feet (75 steps) away from trails and waterbodies and one hundred yards (120 steps) away from any camp, where other people are unlikely to frequent and where water will not pool or flow through. I favor steep, wooded hillsides—for their suitability and also because a pleasant view is nice in those moments. Step 2: Dig a hole. Step 3: Poop in the hole. Step 4: Toss your toilet paper in the hole. Step 5: Cover the hole. Thoroughly. I dig six to eight inches deep and four to six inches wide. I also follow an old Boy Scout directive to cap the hole with a rock, like a tombstone, so someone else won't dig in the same place, but that's your call.

Additional suggestions include dispersing your drop sites widely so that you do not inadvertently create a kind of buried-turd minefield. When it comes to peeing, the rules aren't as strict—you needn't dig or bury, but don't pee directly on living plants if you can avoid it, and in big-predator country, you should whiz one hundred yards away from camp or (preferably) into a large, fast-moving stream. As for poop shovels, some people use them. I don't. There's one I've considered buying solely because it's so hilariously branded—the "Deuce of Spades"—but even those designed for backpacking will add an ounce or two to my pack, and a rock or a stout stick has worked well enough for me for many years.

FLY FLOATANT

I used to go into the Wind Rivers with the heavy cotton fly-fishing vest that I used for my everyday fishing, along with several kilograms of tackle and gizmos in the pockets—thermometer, stomach pump, nail knot jig. I'm honestly not sure what else. Collapsible seine? Probably. I have no excuses except to say that I was inexperienced and unsupervised.

But I wised up and strung up a lanyard with only a few essentials—flybox, tippet, nippers, hemostats, one of those mini Swiss Army knives and floatant dispenser. This worked so well that I eventually began using it everywhere,

Photo by Klaus VanZanten.

and I dumped the vest altogether.

"Dude, no vest?" Jason asked me one day as we rigged up to fish Curtis Creek.

"Not anymore," I said, displaying the sexy new lanyard. "Just this now."

A year later, I was looking through my backpacking gear for more fat to trim, and I decided I didn't need floatant in the Winds. The fish up there are like relatives who are not only unconcerned about the little niceties, they consider such behavior a bit snooty—niceties like fingernail maintenance or wearing a shirt to the dinner table. The fish in the Winds don't care how your fly floats, so although it shaved only a few ounces of weight, I discarded the floatant and made two backpacking trips without once missing it.

The thing is, the floatant dispenser got lost among some other gear, and I fished my

homewaters without it for a long time. When I finally found it again and clipped it back onto the lanyard that I was now using instead of the vest, I'd gotten out of the habit of using floatant, and these days I almost never use it.

Now, I don't want to toss the reader into a literary holding cell while I laboriously connect the metaphorical dots, but to clarify, I left behind the fly floatant, vest and lots of other needless junk because I figured I didn't need them in the Wind Rivers—only to discover that I didn't need them at all. I feel like there's a moral somewhere in that story.

ELECTRONIC GPS NAVIGATION

The last thing I want to do is advise you to leave your GPS unit at home and then find out later you got lost and died. That would make me feel bad. So, if you're trekking in an area without trails or if your route requires precise navigation, you better take the GPS. If you're really bad at navigation, better take the GPS. But if it's convenient, by which I mean you won't be risking your life, I suggest finding your way with a map and compass. For some of you, this will mean learning a new skill. Others were taught the old ways as youngsters and never "upgraded" to electronics. If you're like me, you started with map and compass, switched to digital and are now

Photo by Chadd VanZanten.

reverting to analog. In any case, a map and compass weighs less than an electronic GPS unit and spare batteries. Moreover, the crinkle of the paper and the swing of the compass dial as it aligns with the planet's magnetic field will provide something that is increasingly rare these days: an earthy, tactile experience that is nevertheless purposeful, along with the perhaps-nostalgic satisfaction of solving problems with only your own brain, as opposed to one that's battery-powered and fashioned from silicon.

MOSQUITO REPELLENT

It is interesting to note that although the name of the place is "the Wind Rivers," few people expect it to be so incredibly *windy*. Jackets, sleeping bags, underwear set out to dry, the rain fly of a tent followed by the tent itself: the

Wind Rivers wind will blast them all away like wisps of goose down. Some days the wind is so stiff that your flyline blows like a flag on a schooner at full sail. You couldn't cast that line if your life was at stake.

More commonly associated with the Wind Rivers is the ferociousness of the mosquitos. Even those who don't backpack have heard of them. And in case you're wondering, yes, the mosquitos are "that bad"—but only if you catch them on a good year. On the really, actually bad years, they're just terrifying.

Nevertheless, you don't need bug spray to backpack in the Winds. Here's why: If you're going to bring bug spray to the Winds, it has to be DEET, and it has to be the noxious, 100 percent variety. Everything else is useless. Citronella oils, Avon's Skin So Soft and other botanical solutions—these are mere condiments to the Wind Rivers mosquitos.

Here's the problem: DEET is nasty. If you don't believe me, spill a few drops on your flyline or flybox—it's like that scene in the movie *Alien* when the facehugger's blood drips onto the floor of the med lab and nearly eats through the hull. Just imagine what happens when you handle fish with that stuff on your hands. The product warning label implies DEET is *basically* safe, but the language is suspiciously vague and even cagey. If you read between the lines it says: "Look, if you must use this crazy poison acid, like if you're trapped in the Third World and everyone else is bleeding out of their eye sockets because of mosquito-borne illnesses, for Christ's sake please, please keep it away from your eyes, ears, nose, mouth, broken skin, and any cavity or orifice where it might seep inside your body because it will definitely fuck up your entire nervous system. Our bosses are forcing us to manufacture this vile poison so they can pay for their boats and summer homes. We are very sorry."

Here's the good news: First, a cardinal rule of the Winds is that the fishing is good when the mosquitos are bad. That's all I should really have to say, but if you need additional convincing, you'll be glad to know that the best way to defeat the mosquitos is to cover yourself with clothing that has been sprayed with a much-safer treatment called permethrin. Pants, long sleeves, high socks, hat and lightweight gloves properly treated with this safe-for-even-little-babies-and-pregnant-ladies repellent will keep away the Wind Rivers mosquitos (along with other beasties like flies and ticks) better than any chemicals you apply directly to your skin. A headnet will keep the fiends away from your face and ears, although sometimes you'll have to wear it for so long you will forget it's there, which can turn comical when it's time to spit or take a drink or put a spoonful of oatmeal in your mouth (comical for others, obviously).

Plastic Flies

One year, some friends of mine and I hiked to a chain of lakes in the Winds and found a campsite that was convenient and cozy and had evidently not been used recently. There was a fire ring, for example, but wildflowers sprouted up through the long-dead coals. Two or three squirrels scolded us furiously, and there was deadfall everywhere—sure signs that it'd been a while since anyone had stayed there.

Forest Service personnel are really good at busting up established campsites in the Winds. They'll even ask you to vacate or avoid sites that have gotten too well worn. One year, I camped at a site with a lavishly comfortable sittin' log sturdily propped on stones in front of a fire ring that could only be described as "stately." I went back to the same spot the next year to find the fire ring obliterated and the sittin' log tossed in a lake more than one hundred yards away. These Forest Service folks are committed. Leaving behind fire pits and sittin' logs is, technically, against the rules, and the fines for littering can be as much as $5,000. It's wilderness, after all—we know other people go there, but we don't want to *know* other people go there. We don't want evidence.

That doesn't mean you won't find any. You will. There's litter here and there, especially if you look for it—fugitive tent stakes, food packaging, busted gear buckles. There's nowhere near as much as you'll see at developed camping areas on other public lands, but inevitably there are well-used and "permanent" campsites throughout most wilderness areas.

And so, at this chain of lakes, it was pleasant to discover a camping spot that was comfy but somewhat less trampled, and when I found a suitable expanse of level ground for my tent, I dropped my pack and sat down for a breather and tent-footprint survey. Which way should the door face? What direction does the wind blow? Where will the sun rise?

As I sat there, I spotted a Jolly Rancher wrapper nestled in the pine needles. I saw another and then a few more. I knew no one had camped there in at least a few years, but the place was sheltered from wind and that crackly, indestructible PET plastic never goes away. Ten decades from now, it will probably still look brand-new. So, someone had sat there a few years before me, maybe right where I was sitting, and carelessly tossed their litter around. And then they got up and left. It was a bit discouraging, but the only solution was to shake my head sanctimoniously and stuff the trash into my food sack.

The next morning, I was up and fishing. The best spot in that valley was a short stream between two big lakes. There were good fish there—cutthroats, some pushing two pounds. I was casting an X-Caddis, which

imitates a caddisfly emerging from its exuvia onto the surface of the water. My version was tied with a body of sparkly dubbing to imitate the freshly hatched natural, and it had a tail of white poly-Dacron that trailed in the water to simulate the nymphal shuck. The X-Caddis is a superb fly in the Winds because the white plastic tail gives it great visibility in flat light and rough water, and the lack of dry-fly hackle on the dubbed body makes it more durable than, say, the Elk Hair Caddis.

The fish had been industriously hitting the same X-Caddis all morning, but the fly showed no intentions of surrender. I didn't get a hit on every cast, but I wouldn't be exaggerating much to say they hit it every third or fourth time. And the day was warm without much breeze, so I was hardly bothered when a little eddy on the far side of the stream slurped in my X-Caddis and snagged it up on something under the surface. An exposed root, I figured. But I didn't want to barge into the unfished water to retrieve the fly, so I gave it a few impatient tugs and the tippet snapped. I replaced the fly and kept fishing, and when I'd waded up a little farther, I felt around in the eddy to recover the snagged fly, but I couldn't find it.

That's when I thought of the Jolly Rancher wrappers I'd self-righteously volunteered to take home on behalf of some lazy asshole who wasn't nearly as conscientious as me. Because when I lost that X-Caddis, it essentially turned into litter just as environmentally obnoxious as any candy wrapper. The dubbing, tail and thread were all made of the same polyethylene terephthalate, which can persist in the environment for five hundred years. Even the elk hair probably contained trace amounts of toxic tanning chemicals. Dyes? Formaldehyde? I didn't know.

What I did know is that if I wanted to be really environmentally smug, here was my chance. I already eschewed tying materials made from lead, zealously avoided dropping monofilament in the water and wholesale rejected fluorocarbon for its downright villainous environmental lifespan. But everyone I knew did that, too. This was an opportunity to get seriously holier-than-thou. No more contaminating wilderness streams with candy-wrapped flies.

When I got home, I started ordering tying supplies. Vinyl tying thread? Replaced it with silk. Disclaimer: it's nice to work with but kind of expensive. Sparkle dubbing? Replaced with non-dyed animal fur. Replacing the dozen of my most common colors and varieties wasn't cheap, but on the upside, I no longer had to differentiate the resulting flies by color because they all looked pretty much alike. Poly-Dacron for parachutes, tails and wings? Replaced with calf tail. Not very expensive but hard as hell to work with—

like tying with clumps of spider web. Closed-cell foam for hoppers and other terrestrials? Replaced with spun deer hair. Well, not exactly "replaced," because I rarely tied my own hoppers to begin with. But the time needed to do so quadrupled, and it already took me something like an hour to tie just one presentable example of the foam kind. Also, my deer-hair hoppers seemed to fall apart faster while fishing, and by "faster" I mean "immediately."

But as frustrating as it was, I kept up the crusade for an entire year, and I tied a whole flybox of my righteous new organic flies for use in the Winds. Testing them on my homewaters was more or less successful, so I preached that gospel to my friends. They were impressively apathetic.

"These are just regular flies with all-natural materials?"

"Right," I said. "They're organic. They're more environmentally friendly."

"That's it?"

"Yeah."

"You owe me five bucks for gas."

So, in the spring, just prior to the backpacking season, I signed up to be an exhibition tier at the local fly-tying expo.

An old-timer sat down at my bench to hear my sermon. "So," he said, reading the placard describing my demo, "you're tying regular flies with all-natural materials?"

"Right. They're organic. They're more environmentally friendly."

"That's it?"

"No."

"What else?"

"They also don't look as nice and they fall apart a lot faster. Especially these hoppers. Please don't handle them. They're really delicate."

I fished with my organic flies in the Winds that year, and I did feel slightly holier than everyone else, but the crusade slowly ground to a halt. The effort wasn't terribly practical for one thing, and it never caught on with my trip mates. Most of all, I doubted that I could ever make an appreciable difference within my lifetime.

Nowadays, I actually do tie flies with a lot more natural fibers than I used to, but I went back to tying with the PET materials for everyday fishing, and eventually I started bringing some PET flies back into the Winds, too.

I haven't given up on being extra careful about litter in the Wind Rivers or in the outdoors generally. I've seen those massive rafts of plastic gyring endlessly out in the oceans, and it's embarrassing to think that even one small handful of that grimy shit belongs to me. But for now, I try to pick up and pack out the litter I come across in the mountains. If I take away

a hundred times more plastic litter than I leave behind in the form of lost flies, I figure the balance sheet is black enough so that I can go back the following year.

And I always keep some those organic flies in my flybox. I don't often fish with them outside the Winds; they require way too much tying effort to actually put them in the water very often. Instead I keep them around as a reminder that the world faces complicated environmental problems, and that I'm responsible to do what I can to solve them, even if it might not make me feel very righteous.

MINIATURE CHESS SET

Mine is made of wood, four inches square by an inch deep, and it weighs seven ounces. The playing surface consists of inlaid squares of light and dark sandalwood. It holds the pieces in place by means of a hole in the center of each square and a peg on the bottom of each piece. The lid closes like a clamshell over the board and fastens with a hasp so that you can pack away an in-progress game. It's certainly the finest travel set I've ever owned, and I've never seen another like it.

I found it at a secondhand store. It was clumsily bound shut with masking tape, the hinges were dislocated and the wood finish was in bad shape. No playing pieces were missing, but a good third of them were missing their pegs—some had snapped off in the board. I'm not a very good chess player, but the little set charmed me and it was only a few bucks. And although I know even less about woodworking than chess, I managed to polish up the board, fix the hinges and repair the chessmen.

At the time, I played chess only occasionally, usually with my young kids, mostly just to teach them the rules, and I had a normal-sized Milton Bradley set. I had no need for such finely crafted miniaturization and portability, and yet I always brought the travel set on vacations and business trips, where the chances for a real match were slimmer still.

And so I tossed the wooden travel set into my pack when I started going to the Wind Rivers, too, but up there it was totally different. Suddenly, the chess set had real purpose. Up there it was an elegant little luxury, and everyone wanted to play. The rustic wooden board, laid open between two contemplative outdoorsmen, seated in the low alpine lawn of a windswept mountain valley—it seemed sophisticated and very picturesque. I don't know if Henry David Thoreau played much chess, and I'm pretty sure he spent most of his time alone, so probably not, but I think he'd approve of the scene. John Muir and Wallace Stegner too.

With the board set on a flat-topped hunk of granite moraine, I checkmated my first Wind Rivers opponent in ten or twelve moves, and it was awfully satisfying despite the fact that he was just a high school kid who had to ask me to remind him how to "do that thing where your king and castle switch places."

But the best matches were with my son Shreve. He was still a young kid back then, and he sometimes forgot how to castle, too, but playing chess with me on the little board was all he wanted to do. Maybe he felt the romance of it the way I did or maybe he just liked having my undivided attention, but on those trips, he preferred chess to hiking, fishing and even playing in the fire.

Shreve grew from kid to teenager to towering man, and as he became more occupied with friends and sports, we missed backpacking for a few seasons. Then his mom and I got divorced and I moved out, and Shreve missed out on a few more seasons. He's in college now, and I haven't tripped with him in a while. I've also gotten pretty ruthless about what I do and don't put in my backpack over the years, and the miniature chess set has been on the do-not-pack list for a long time.

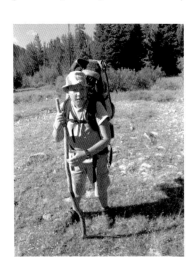

Shreve told me the other day that he'd been wanting to go back, to make another trip to the Winds. He didn't mention the miniature chess set, but I immediately dug it out of the closet. *Photo by Chadd VanZanten.*

However, Shreve told me the other day that he'd been wanting to go back, to make another trip to the Winds. He didn't mention the miniature chess set, but I immediately dug it out of the closet, and when I opened it up, I found the pieces arranged in a half-finished game.

I examined the board. The pawns and rooks stood frozen in their ranks and files, still awaiting orders after all those years. It looked like White had lost a pawn and a knight but was holding on to the center. Black had given up several pawns, and his queen was in some difficulty, but he'd castled and his position was not unenviable.

It looked like it would have ended up in a pretty good fracas. I wondered if the game was one that Shreve and I had started, and why we might have stopped.

WHEN WE WERE LOST

When we started the hike, the weather was warm. The clouds were few, and between the trees a vivid blue shone through. It was as you'd expect on a July afternoon in the Wind River Range. But later that day, when we were lost, the temperature dropped. And the next day it dropped again.

A cold front had rolled down from the northwest and was plunging over the Continental Divide like a wave of ice water into the clearing where we'd pitched our tents. Late-afternoon winds spoiled the fishing, so we built a little fire and hunched over the flames with hands jammed in pockets, standing practically within the rock ring of the fire pit, but the wind sucked away all the heat, and there was no more deadfall to burn. It was at least a tidy campsite.

"Cold," I muttered, without looking up from the fire.

"It's cold as shit," replied Jason.

I circled the clearing, picking up stray scraps of bark and bits of rotted, punky pine. This I tossed into the fire, where the fanned-up flames reduced the few sticks of fuel to ashy residue. The sun was coming low, three fingers above the valley's western rim. It would be cold that night. I put up the hood of my jacket, crossed the clearing and headed into the trees.

"Dude, where you going?" asked Jason.

"To find some more wood."

"Try not to get lost this time," he said. I gave him the finger without looking back. He laughed but I didn't.

Photo by Klaus VanZanten

Getting lost in any wilderness area is no joke, as anyone in the search and rescue business will tell you. If you lose your way in the Winds, your savior will probably be a volunteer from Tip Top Search and Rescue, headquartered in Pinedale.

I spoke to Tip Top's coordinator, Kenna Tanner. She said Tip Top is a nonprofit, all-volunteer outfit with close ties to the Sublette County Sheriff's Department. When somebody gets into trouble anywhere in the county, the sheriff's department leads the rescue, but it turns to Tip Top for volunteers, expertise and equipment.

Kenna said Tip Top gets forty to fifty missions per year, the great majority of which end happily, but that includes emergencies of all kinds—whitewater rafting, snowmobiling, skiing—throughout all of Sublette County.

According to the Sublette County Sheriff's Department, reports of lost and missing hikers and climbers within the Bridger-Teton National Forest are much fewer, just seven between 2012 and 2017. But three of those resulted in fatalities, which seems typical of the area's history. Every year, the Wind River Range rises up to grab somebody, and there is no guarantee that it'll ever let them go.

Not surprisingly, inexperience is often to blame, as it was for Bodie Moody, a twenty-eight-year-old Rock Springs man who was reported missing in July 2010 while hiking with friends and family at Boulder Lake. After finding the trail too difficult, Bodie quit the hike to return to the trailhead. His companions also turned back only ten minutes after that, but they didn't find

Bodie when they got back to the truck. The area is not remote or particularly rugged, but Bodie had little wilderness experience. Reports say that he also suffered from mental illness and was not properly medicated. He was found dead from a fall three days later.

Unanticipated developments may also lead visitors rapidly into trouble. Many backcountry novices (including me) have been spared from disaster solely because no adverse conditions arose. This was not the case for a man and his adult daughter who in August 2009 were hiking the Winds near Titcomb Basin when a snowstorm moved in. A relative reported them missing. Rescue workers mobilized that day and searched on foot and by helicopter for two days but couldn't locate them. Authorities said the dad and daughter likely lost the trail in the snow and were forced to shelter in place without adequate clothing. However, climbers discovered them, tired and dehydrated but alive, on the third day. That timing was fortunate—if you're not found alive within three or four days, chances are you won't be.

Inexperience was probably why forty-one-year-old Gregory Harvey of Virginia went missing in July 2015. Reports say he felt ill during a hike at Big Sandy, decided to return to the trailhead and lost his way. He was found alive, too, a day later.

But disappearing in the Winds can happen to very experienced visitors, especially if they're alone. Forty-six-year-old Clay Rubano was a former Glacier National Park ranger and an instructor at the National Outdoor Leadership School (NOLS). If you were stranded in the backwoods, you'd be praying that someone like Clay was looking for you. Nevertheless, in early November 2007, Clay parked his car at a trailhead outside Lander, went for a day hike along the Middle Fork of the Popo Agie River and was never seen alive again.

Although Clay's case is technically closed, questions about him remain open, largely because the initial search for him may have been delayed by as many as two days. Clay hadn't been clear about his plans that weekend, and his wife was out of town, so he wasn't reported missing until he failed to show up at NOLS on Monday. Harsh weather hampered and eventually ended the search, and for seven months, no one knew anything.

The following spring, a set of partial remains and some of Clay's belongings and were recovered. Wild animals and the elements had gotten involved by then, but Clay's loved ones finally knew what happened to him, at least in general terms. On his day hike, Clay climbed a scenic outcropping and then fell eighty feet onto rocks below. Not much more could be established. How did he fall? Did the fall kill him instantly or

did he die later? Could rescuers have saved him if they'd started looking earlier? No one will ever know for sure.

If I'd been reported missing with Jason in the Winds, I would object (posthumously if necessary) to any newspaper account describing me as an "experienced backpacker." I think the right term would be just "experience," as in, "VanZanten was purported to have backpacking experience, but no actual credentials could be verified, and likely for good reason, because it was his fault they got lost."

It was a rookie mistake. I concede that. It was Jason's first trip to the Winds. I was supposedly acting as guide, and so as I steered us down the wrong fork of the trail, I was probably preaching at Jason like Gandalf lecturing Frodo. I was likely shooting my mouth off about the fishing as I went south instead of east and almost became the star of my very own *Pinedale Online* report, describing in terse, journalistic phrasing the details of my disappearance and how Tip Top had to come and find me.

That's why I was looking for penitence, which is to say looking for firewood. There wasn't much to find. I'd wandered out a hundred yards from camp and found only wrist-sized branches and more corky, ground-rotted pine. Even a big armful wouldn't last. I could spend an hour collecting wood that would take less time than that to burn.

What I wanted was a log that we could push into the fire pit a few feet at a time, something to hold back the cold until it was time to go to bed. So I walked around for a few more minutes and came upon the great bole of a long-ago fallen pine tree.

All the bark was long gone, and the wood was bleached gray and polished by the weather. About six feet of the desiccated trunk remained, lying on its side in the rust-colored duff. Because of a mouth-like crease along the trunk, it resembled the skull of a triceratops or dragon. What was left of the roots splayed in the air like a spiny collar almost as tall as me.

I discarded the kindling I'd picked up and then yanked at the big bole to try its weight. How long had it lain there? How long for wind and water to wear it down that way? It was the densest part of the tree, the last to erode away, but it wasn't so heavy that I couldn't budge it. It was unwieldy, though, and would probably take half an hour to drag back to camp. But I felt the wind gusting, finding its way to my skin at the neck and sleeves of my jacket. And I remembered when we were lost, that I'd gotten us that way and that we'd lost half a day to that.

So I lifted the big skull by the snout. When I did, it no longer lay on the ground but stood on the radiating spines of the roots, so that I could skate

It was the densest part of the tree, the last to erode away, but it wasn't so heavy that I couldn't budge it. *Photo by Klaus VanZanten.*

it along like a poorly constructed travois. By dragging it at a steady speed, I made a little progress. But then it would snag on a rock or root every ten yards or so, and I'd have to stop.

"Jay," I hollered. "C'mere and help me." I didn't actually want his help. Not really. I bent down to take hold of the trunk again.

Getting lost isn't the only way to perish in the Wind Rivers, of course. In 1953, Chicago mountain climber Karl Bollinger fell to his death while attempting to summit Warbonnet Peak near the Cirque of the Towers. Investigators say an improperly rigged harness was likely to blame. If there was any good news for Bollinger, it was that the prominence he fell from, a lesser peak near the Warbonnet, now unofficially bears his name. Climbing fatalities seem to occur on a fairly regular timetable, one every few years, give or take: two in 2015; one each in 2011, 2007, 2006 and 2003; two in 2001; and so on for years past.

I was surprised to learn that more people are not killed by lightning in the Winds, but a few have tangled with it. Wyoming author C.L. Rawlins recalled a woman named Tersis Ross who was killed by lightning (it just so happens) while climbing Karl Bollinger's peak in the late 1970s.

Two other lightning strike victims, college students Katrin Birmann and Ryan Sayers, were in one way more fortunate than Tersis but in other ways much less so. In June 2003, they were climbing 12,000-foot Steeple Peak. When they were 1,500 feet from the summit, an afternoon storm overtook them. Both were struck by lightning; both survived. Burned, badly shaken and with little choice but to wait out the weather, they shed their climbing gear and hunkered down. One hour later, lightning struck them a second time. Katrin recovered to find Ryan had fallen 300 feet into a ravine. She rappelled down to him, but he was dead. Katrin stayed with Ryan's body overnight and then hiked out and called for help on a borrowed cellphone. An autopsy revealed that Ryan died of the lightning strike, not the fall. Interesting to consider what they may have talked about in the hour that passed between the lightning strikes—and everything they did not.

Regarding a climbing death that occurred in early August 2007, one almost cannot say whose misfortune is greater: the person who died or the one who survived. Peter Absolon, forty-seven, was a director at NOLS. A very experienced mountaineer, Peter was accompanied by a fellow NOLS instructor while climbing a cliff face in Leg Lake Cirque. They'd progressed to a height of about eight hundred feet above the base of the cliff when twenty-three-year-old Luke Rodolph came hiking along the rim of the cirque about three hundred feet above them. Rodolph was unaware of the two climbers below, and while enjoying the view, he decided to trundle a boulder into the yawning expanse of the cirque.

One pauses at this point in the story to ponder how lives often intersect at such astronomical coincidences, how a second thought or the matter of a few inches might change the course of one's entire existence.

Rodolph pushed the boulder off the ledge and then leaned over the rim just in time to see it strike Peter on the back of his head. Peter was equipped with proper protective headgear, but the blow killed him instantly. The other climber was unharmed and thought the falling boulder was an accident, but Rodolph quickly turned himself in and confessed. He could have been charged with various forms of endangerment or negligence, which carry hefty fines and jail time. But no such charges were filed against Luke Rodolph, possibly due to how he handled himself after the incident. Rodolph was instead sentenced to carry the burden of Peter Absolon's needless death and the grief of the wife and daughter Peter left behind.

It took me more like forty-five minutes to haul the big wooden dragon skull to camp. When Jason saw me through the trees, he hustled over to help pull it the rest of the way, leaving a wavy, livid scar in the forest floor.

Our fire pit was too small to contain it, so I rolled the bole over the coals, and with only a little coaxing it smoked up and took fire. Soon the wind had whipped up the flames so that it flared with the fitful howl of a furnace, and it sat there in the center of camp leering like some demon I'd summoned.

"A fire this big and I'm still freezing my ass off," said Jason.

"Yeah, it's cold," I said.

"Dude, it's cold as shit."

As the sky above our camp went black, Jason and I donned our winter caps and down jackets. We cinched our hoods around our faces and sulked by the sinister flames of the burning stump. Its blaze lit the wall of trees around the grove with a strobing glow. Soon it was the sole fuel source in the fire pit, and there was nothing to replace it.

After dinner, we broke out the whiskey. We had plenty of that, at least. Jason raised the flask into the air. "Another fine and pleasant misery." He laughed deeply from his belly, drank and then handed the flask to me. I took a swig, shook my head and then I took another. The false warmth of dilated capillaries seeped into my extremities.

No survey of Wind Rivers missing persons would be complete without the story of Randy Udall, a well-known environmental activist and outdoor enthusiast. At sixty-one, Randy embarked on a solo hike in the Winds in June 2013 but did not return as scheduled. For five days, searchers had no success, which made national headlines in part because Randy was cousin, brother and son to three different U.S. senators. One week after he was reported missing, Randy was found on a hiking route, dead apparently of natural causes, his walking sticks still in hand.

Other famous fatalities include Bill Gore, inventor of Gore-Tex fabric, who at age seventy-four died of a heart attack while camping in the Wind Rivers in 1986.

Perhaps the most famous missing person case of the Wind Rivers, a now legendary tale of faith and survival, is that of Mike Turner, a tall, burly Presbyterian pastor and outdoorsman from Caldwell, Idaho. Mike was forty-eight in July 1998 when he planned a "Wander in Wonder," a ten-day sojourn with his black lab, Andy, through the Winds Rivers, across the Continental Divide and into the Big Sandy drainage to meet his family.

In a journal of the trip, he wrote, "I had dreamed of a special time alone with God, facing the elements, the passes, thinking about my life, the direction of the church, about my family." By the end of his trip, Mike confessed that he'd gotten what he came for, multiplied by one hundred. Others might argue the factor was closer to one thousand.

Mike set out on July 30, writing his impressions of what he saw as god's majesty. "[S]o quiet, so perfect. Is it all just as you want it, God? Or like skeptics say…is it just random events and we are nothing before the beneficence and destructiveness of nature?…In beauty and peace you refresh me.…God bless this trip. May it fulfill your holy purposes."

Soon the going was harder. There was snow in the passes and glacial crevasses to negotiate. Andy was footsore from the coarse ice, so Mike changed his route. Mike himself even lost traction and tobogganed down an incline on Knife Point Glacier. "What a tough time," he wrote.

On August 2 (day four), Mike was traversing a boulder field near a lake at 11,400 feet in the area of Brown Cliffs in the Fitzpatrick Wilderness. Boulder fields are common in alpine wilderness—artifacts of the ice age. Stones ranging from suitcase-size to that of minivans were scooped up and scraped along by glaciers. The receding ice left behind closely packed boulders strewn over wide areas, some acres in size. To cross them on foot, you hop from one boulder to the next, a test of route-finding skills and knee-joint condition. Young hikers enjoy it; those of more advanced years dread it.

I imagine Mike took it in stride, taking photos and basking in the solitude. But because the boulders are arranged just as gravity left them ten millennia ago, they may balance delicately atop one another for thousands of years, awaiting only the tread of a hiker to tilt or topple, which can result in a bone-shattering fall—or much worse.

That is what happened to Mike. A massive stone he stepped on rolled underfoot. He managed to jump off it, but he landed on another boulder that was too steeply pitched for traction and slid down. Also sliding down was the boulder he'd dislodged, which weighed eight hundred pounds. When Mike and the boulder met, his legs were pinned.

Mike ended up on a steeply angled boulder in a kind of awkward seated position with his feet dangling over the boulder's edge. The fridge-sized rock he'd dislodged pressed firmly against his thighs. Mike was pinned, but incredibly, he wasn't seriously injured in that moment. His right foot was crossed over his left, but the boulder did not crush his legs or even break his skin. It pressed against him just snugly enough to trap him, as one reporter put it, like a "pair of granite shackles."

Mike spent hours trying to escape. He wriggled and pulled against the pressure. He levered the stone with his camera tripod. But from his ungainly position, there was no way to free himself. Temperatures rose to around one hundred degrees in the day, and at night they plunged to

Receding ice left behind closely packed boulders strewn over wide areas, some acres in size. To cross them on foot, you hop from one boulder to the next, a test of route-finding skills and knee-joint condition. *Photo by Brian L. Schiele.*

nearly freezing. Mike spread his tent awkwardly overhead for shade and wrapped himself in his sleeping bag for warmth, but pinned the way he was—in the open, at a high elevation, legs pinched and exposed—actual shelter and comfort were mere notions. The journal entries show Mike alternating between anger and humility.

"God is with me but I am angry with him," he lamented. "Why this terrible injustice, or is it the product of pride? This sense of wrestling against God or the angel of God is distressing. What can I do against God?"

At other times, Mike was incredibly circumspect for someone trapped for days in such a plight. "So lonely," he wrote, "more than I imagined. Who would have guessed that four days would have gone by and no one has come this way?"

When his water ran out and he'd melted all the snow within reach, Mike tied a cord to his water bottle and lobbed it at the lake, which was only thirty feet away. But the bottled snagged up in the rocks and was lost. Mike pondered what his urine might taste like with Crystal Light powder mixed in.

Still, Mike remained focused on his god and family. As he grew weaker he wrote to them and of them. "If I make it," Mike wrote, "you will hear a lot about this time, details you are probably not that interested in but I know you will listen." In another, more ardent entry: "I will trust in God though he will slay me, yet will I trust him, he is the way, the truth, the light."

Down at Big Sandy, Mike's family waited. He'd said he'd meet them at noon on August 8, and when he didn't appear, his wife, Diane, at first

thought he was only taking a little extra time. "Honestly, I just felt irritated," Diane told a reporter. "I figured he was out there taking pictures."

Mike was reported missing late on Sunday, August 9, but by that time he'd been trapped beneath his boulder for a week and was beginning to accept his fate. "Fill me with peace, Lord," he wrote. "I am ready to die."

Sometime after day five, Mike fumbled the journal and it slid out of reach. To continue his record, he wrote on the blank pages of his pocket-sized New Testament and in the margins of his cookstove instruction manual, but his body and mind were faltering. Reports say many of Mike's later entries are cryptic or illegible. "Shutting down. Getting low. Thought I would be found yesterday…"

Later, Mike wrote of seeing Diane and others nearby. Another entry is just the number "3" with a circle around it.

Mike's family and congregation mobilized in force, posting flyers and phoning visitors who'd signed the National Park Service registries at the trailheads. Outdoor retailer REI circulated images of Mike's Asolo boot-tread pattern to aid search parties. However, on August 23, after two weeks, the search for Mike was halted.

The sheriff's office said they'd resume searching if there was a break in the case, and on August 28, there was: Andy the Lab was found. The poor dog was malnourished and exhausted, but it was hoped he might lead searchers to Mike. Sadly, just as they got underway, a hiker from San Diego presented Mike's wallet to the sheriff's office in Pinedale. He'd spotted Mike's body in the boulder field on August 31. "I had seen the posters at the trailhead and knew they were looking for someone," the hiker told a reporter. "So I called out, 'Hey, are you all right?' There was no answer. I knew there wouldn't be."

The coroner's report says Mike staved off thirst and the elements for an unthinkable nine days and died on August 11, the day the first search chopper lifted off.

While Mike Turner's case is astonishing and perhaps morbidly inspiring, I more closely relate to the story of a band of lowlanders out of Maryland who took a guided trip to the Winds on horseback for a week of fishing. It was August 1997, just one year before Mike Turner's wander in wonder.

Among the group was David Crouch, twenty-seven, from Stevensville, just across Chesapeake Bay from Baltimore. Fit and slender, he was a cyclist, runner and sailor and had recently taken up fly-fishing. By all accounting, David was equal to the rigors of backcountry camping, but once he arrived, the outfitters and even his own friends accused him of being too recklessly

eager to explore. Because although the expedition cost David $225 per day and included every amenity, he pursued only one objective: to drink in as much of Wind Rivers as he could.

As a first-time visitor to the Winds, Dave would find it difficult to avoid being overawed by the place. He'd hiked in the Poconos, but those mountains top out before three thousand feet. In the Winds, David was crossing beneath peaks twelve thousand feet high and higher, visiting alpine meadows and those lakes and streams coursing with high-country cutthroats. Whatever it was he'd been looking for up there, he evidently found it. I understand this completely.

His campmates and guides later told the press that although David developed an instant passion for the Winds, he neglected to pay it due respect. And so, they told David to stay with the group. They told him to be careful. They told him repeatedly. He wouldn't listen.

On August 30, David and the rest of the guests gathered around their campfire at the southern tip of Lost Lake. One can picture the campsite in the trees—the horses are hobbled and huffing in the dusk while trailhands wash up the cookpots after dinner. The guides with their western-state drawls sit pitching day-trip ideas from the flickering shadows, and the easterners confer in their mid-Atlantic brogues.

That night, they decided that in the morning the guests would hike a mile and a half east to Island Lake, fish for a few hours and then rendezvous for lunch at 2:00 p.m. by a trail junction known as Fremonts Crossing.

As planned, the guests hiked to Island Lake on the morning of Sunday, August 31. David was seen fishing the southern shore, but they soon lost sight of him. He never made it to the crossing for lunch and never answered later that day when they combed the area calling his name.

That wasn't the last time David was seen, though. He was spotted by backpackers around 7:00 p.m., five hours after missing lunch and seven hours after his fishing companions last saw him. Where had he been? The backpackers greeted David as they passed, as is backcountry custom, but David did not return the greeting. He was several miles northeast of Island Lake and the outfitters' camp, heading even farther north as the sun set. The backpackers said David was on a dead-end trail, crossing rugged terrain above treeline, wearing light clothing and carrying nothing but a fly rod.

What ensued was the most intense search-and-rescue effort the Bridger-Teton National Forest had seen in two decades. Back in Maryland, David's family and community rallied in support. Those who knew David asserted that he was more than capable of handling himself until rescuers found him.

One of his friends had little doubt that he'd turn up eventually. He told a reporter, "He'll be fine."

But Sublette County sheriff Hank Ruland made this grimly poetic statement: "The clock ticks pretty slow up there. And if you don't have some survival equipment when the temperature drops into the 20s, well, that's a no-brainer. You'll go down."

David had no survival equipment. He is thought to have had no water, jacket, compass, map, flashlight or matches. Temperatures dropped to below twenty degrees and then went lower. It turned raw and snowy. However, the backpackers had given authorities a solid last-known location and a bearing. Based on their input and that of another team, the search area was narrowed to about one square mile.

Fifty volunteers were involved in the effort to find David Crouch. There were teams on foot, teams on horseback and teams with dogs. Two light airplanes and a helicopter were enlisted. Additionally, it was Labor Day weekend, and reports said that there may have been 140 campers in the vicinity.

Together they sifted the search grids, but despite the crowds, volunteers, dogs and aircraft, they didn't find David. Even focusing on just one of the three thousand square miles of wilderness wasn't enough. David remained lost.

On September 7, Sheriff Ruland called off the search. He had cadaver-sniffing dogs looking until the second week in September, and surely forlorn hopes of a homecoming were harbored for much longer. But Ruland had given the Crouches an entire week, and after that he did not equivocate. "It's pretty bleak," he said in a newspaper article announcing his decision. "I told the family we can't search forever."

I want to say that I fell under the same spell that evidently got to David, and I know that the first few times I went to the Winds I was less experienced and fit than he was—so it fascinates me to know that his first trip was also his last, and what remains of David Crouch is still somewhere up there. Authorities say David probably died on September 2, but he's never been found. A wilderness guide who spoke to the *Baltimore Sun* explained this perfectly. He said, "As busy as that wilderness is, if you get just a quarter of a mile off a trail you might not see anybody for another ten years."

What Sheriff Ruland really meant was that they actually could search forever—it just wouldn't do any good.

David's family and others seem to think David had just lost track of time while looking for some new place to fish, but I believe he was in the final

stages of becoming lost. That would explain why he didn't speak with those backpackers—he wasn't lost enough to ask for help, but he was too lost to keep protocol or make his way back to camp.

You don't hike down a trail, blink your eyes and suddenly you're lost. It's a process. You get lost because one tree looks much like another, and one hillside looks a lot like the last. You mistake the wrong place for the right and turn wrong, and then you make it worse by turning wrong again. And you don't admit it until much later.

Jason kept asking me, "Dude, are you sure we're supposed to be this far south?"

"Yeah, we're good," I said, barely looking up from the trail. "We're going right."

"We're not too far south?"

We were way too far south. But it wasn't until late afternoon that I finally admitted it.

"Okay," I said, stopping on the trail at last. "I think we do need to turn back. This doesn't look right anymore." Jason didn't pause to confer or confirm. He knew. He turned about on one foot and was headed back up the trail practically before I was through saying it.

We backtracked three miles to the fork in the trail where I'd gone left instead of right. The problem was there wasn't much to the fork. It wasn't as if the two trails branched off at right angles, one leading due east to our campsite and the other forking south to some shadowy land of the lost. Instead, the paths split by only about twelve degrees at first, as singletracks often do only to join up again later. These two trails actually remained within view of each other, practically parallel, for a hundred yards or more.

I laughed a little as I stepped onto the right fork, but it wasn't all that funny. The essence of getting lost lies within the narrow margins for error, errors that don't feel like errors, errors that compound. Bodie Moody, the guy who

Not all those who wander are lost, but most of us certainly are. *Photo by Klaus VanZanten.*

disappeared near the popular, oft-visited Boulder Lake, was found only three thousand feet north of the lake's shore. Clay Rubano fell to his death five miles from his car and one mile downstream of a well-traveled footbridge. Mike Turner died of thirst ten yards from a lake that a team from NOLS had visited two days earlier. And authorities speculate that David Crouch might have looped around to the outfitter camp if he'd had only two more hours of daylight.

Jason and I were off route for only a few hours, but even a casual search of *Pinedale Online* proves that that's how it always starts—one false step, sunset and a few days later somebody is reporting your physical description and last known whereabouts to the Sublette County Sheriff's Department while you're deliriously scrawling the number "3" in the back of a miniature Bible. It's as if wilderness waits for you to make a mistake, and one wrong turn is all it will ever need to claim you.

It's easy to fall in love with nature, but it will never love you back. You can never trust a mountain. You can't make friends with night.

The flaming dragon skull grinned at us from the fire pit. Its black and ruby scales pulsed hotly under the tireless gust of the cold front. Tiny embers blew back from its face and spines, creating the illusion that it was racing forward into the darkness. We sat drinking to it like sullen cultists.

"I can't believe I got us lost," I said. I drank and passed the flask back.

"Yeah. That was fucked up," said Jason.

"Totally my fault," I said.

"I know." He drank and held out the flask. "Kill it off."

A famous author long passed once wrote, "Not all those who wander are lost." It's just one line from a poem in a grander saga, a gorgeous line, quite fitting for the character for whom it was written. And because of its pithy elegance and penetrating truth, it has been co-opted as a personal motto for many, pressed into service for tattoos and T-shirt graphics. It's easy to apply to ourselves, perhaps because it makes us seem more adventurous than we really are. But implicit within those evocative staves is a more trenchant and universal truth: while not *all* who wander are lost, *most* of us certainly are.

I lifted the flask to my lips and drained it. The dragon skull smoldered all night.

THE GIRL

A few days before Jason and I headed out for the season's first backpacking trip, I bought some mushrooms from a guy who lived in a high-rise studio apartment in downtown Salt Lake City. A woman with the melancholy good looks and short-cropped haircut of a chick singer in a new-wave band met me down on the street and escorted me up to the apartment.

The mushroom dealer was slender with patchy black chin stubble and large, gloomy eyes. His bed was right next to a floor-to-ceiling window that overlooked the street. In the corner was a small kitchen, where a burly guy with a long beard and shaved head was frying up pork belly to make tacos.

The woman with the new-wave hair explained that both guys were her boyfriends. They shared her, she told me, and she split her time between them. These guys have it figured out, I thought. Half a girlfriend each.

The new-wave singer invited me to stay for a taco. "We got plenty to go around," she said.

"Nah," I said, "I ate already. I'm in a hurry, anyway."

They showed me the desiccated mushrooms. The tops were round and tan, the size of the end of my pinkie, and the stems were pale and parched. The mushroom dealer weighed them on a pocket-sized electronic scale and parceled them in mini zip-lock baggies. They weighed nothing, a few grams total. Still, they seemed heavy with potential, like an oak-and-iron door that opened to an inner sanctuary.

"Walk me through it," I said. "Should I just eat them?"

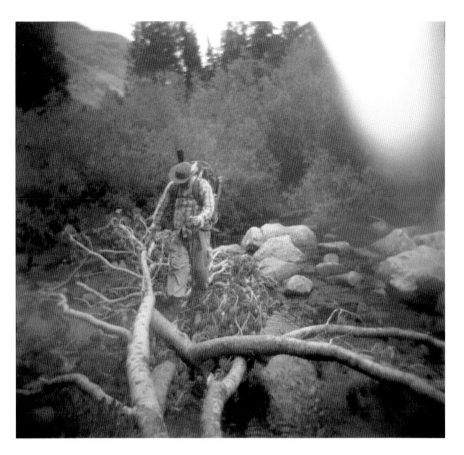

Photo by Brian L. Schiele.

"You can," said the mushroom dealer, "but they don't taste very good."

"They taste awful," said the woman.

"Best thing is to put them in orange juice," said the mushroom dealer. "Shake it up, then drink it."

I shook my head. "I won't have any orange juice with me. I'm going backpacking."

He shrugged. "Chocolate pudding, then," he said, as though little cups of pudding might be easier to come by in the wilderness than orange juice.

"I'll figure something out."

"These aren't really intense," he warned. "You won't go out of your head, like with acid." That was disappointing to hear.

He told me how the mushroom trip might actually unfold, using terms like "enhanced awareness" and "perception shift," but I'd kind of tuned

him out, partially because it all sounded rather cliché and vague but mostly because out of my head is where I really needed to go—there or anywhere that would help me forget The Girl.

She was witty, radically blue-eyed and beautiful—a writer, too—but stormier than an exposed backcountry ridgeline when the thunderheads boil up on hot afternoons. I needed to be wherever she wasn't, and that included my head. Because The Girl was angry. Again. I'd let her down. Again. And we'd broken up for the last time. Again. Out of my head was the one place in the Wind Rivers I was really hoping to go.

"Well, how long will it last?"

"It varies. Six, seven hours." Better than nothing.

I packed the mushrooms in my backpack alongside a sixteen-ounce airman's flask of Jack Daniel's and another full of Sailor Jerry rum. I told Jason, "I'm bringing a couple friends. You've met them—Jack and Jerry."

"Looking forward to seeing them again," he said.

"I'm also bringing 'shrooms."

"That's cool," said Jason, "but I probably won't partake."

"How come?"

"Probably have a bad trip. I haven't been in the best frame of mind lately."

So. There it was. We were both heading to the Winds for purposes of escape.

"Maybe when we get up there you'll feel different," I suggested.

A few days later, we drove to Pinedale. Neon signs and faulty streetlights flickered in the dusk, lending the tiny town a carnival mood. We checked into a motel and threw our backpacks on the beds. After Jason had a gulp of the Jack and I had one of the Jerry, we ambled out into the town and found a brewpub. Jason was ordering beers before I even saw the food menu. I was feeling the rum but didn't want to fall behind Jason, and so I drank too much beer to finish the burger I'd ordered. But I was at least finally noticing some distance between myself and The Girl, and Jason was laughing again.

From the brewpub we went to the Cowboy Bar, where we were served shots of scotch by Sharla, a blond barmaid of highly indeterminate age who perhaps by way of full disclosure (or maybe as fair warning) informed us that she was currently dating the manager of the place but had also been married to at least two of the guys drinking in the bar that night. This was an alternative I'd definitely never tried—love 'em and leave 'em fast. With her announcement complete, Sharla flirted unflinchingly, first with Jason, then me, then Jason. I wondered if maybe she listened to a lot of Prince.

On the back wall of the bar, the taxidermied ass end of a javelina had been mounted over a plaque that read, "A clear conscience is usually the sign of bad memory."

We sat at the bar next to a guy named Dennis, who turned out to be one of the exes Sharla had mentioned. Dennis wore a sleeveless T-shirt and drank whiskey and Diet Coke from a plastic cup. He was from Florida, had a great fondness for racist knock-knock jokes and was missing his entire left index finger. He held his hand up to his nose so that it looked like the missing finger was buried up to the third knuckle in his nostril. I immediately dubbed him "Dennis of the Nine Fingers."

Sharla rolled her eyes.

"What happened to it?" I asked, jabbing my chin at his hand.

"Gator. Down in Florida." He held the hand up and showed me first the palm and then the back, wiggling the fingers as if to prove the absent digit was no illusion. "That's why I moved up here. Too damn many gators down there."

"Don't you believe him," said Sharla.

After a sidelong glance, Dennis confessed that he lost the finger to a mishandled involvement with an industrial power tool. Then he admitted that the reason he could never move back to the South was that he'd stolen a car there as a young man and was probably still wanted by the law. His frankness made me feel suddenly sympathetic, so I bought him another whiskey and Diet Coke. (The next day, Jason told me he suspected Dennis of the Nine Fingers had been plotting to knife me because of the way I scolded him for telling jokes with the n-word in them.)

When Sharla sent out the last call for alcohol, a final round was ordered, and then everyone in the bar—including Sharla, her manager-boyfriend and her exes—went as a single throng to The Corral, a watering hole just across the street that was still open. There I stood at the bar and drank with a handsome couple who had been fishing together on the Green River below Warren Bridge.

"Fly-fishing?" I asked.

"Yeah," said the boyfriend. He had a narrow face and big white teeth.

"You guys fly-fish together?"

"Hell yeah," he said before his girlfriend could answer. "Alla time."

The girlfriend was blond and doe-eyed and plumpish, rather the opposite of The Girl.

"How long you been fishing?" I asked her.

"I taught her," answered the boyfriend, stepping in front of her.

I wanted to hear her speak, because I imagined her voice was husky, also the opposite of The Girl, but the angler boyfriend spoke up before she could ever say anything. Then, as if to divert my attention from her, he produced his phone and showed me a photo of a massive brown trout he'd caught.

"This is at Warren Bridge?" I asked.

"Boom," he replied. "You should totally go." The girlfriend stayed behind him, her arms around his middle, cheek laid against his shoulder blade. I envied their easy, wordless affection. Soon they left.

A young guy came to the bar and introduced himself by claiming that he'd been a runner-up on RuPaul's reality TV show *Drag Race*. He was short and bird-like with olive skin and heavy-lidded eyes, and he was dressed in jeans and a T-shirt.

"You were on TV?" I asked.

He pursed his lips and lifted his chin, striking a sensuous pose that simultaneously evoked Marilyn Monroe and a small, drunken vampire.

I took this for a yes.

"Season seven," he lisped dramatically.

"I'll have to look that up and watch it," I said.

"Go ahead, baby," he said, frowning. "You think I'm lying?"

"No," I said. "Just curious why you didn't win."

"It was all a setup," he hissed. "I'm over it." Here was an entirely different approach, I thought—eliminating the girls altogether.

I must have been quite drunk by this time.

"Well," I said, "Lemme ask you something."

"What."

"You're a drag queen, right? Like no shit?"

He struck the pose again.

"Okay," I said. "There's this girl. I love her, but she's—tempestuous."

"Bitches are crazy," he replied.

"That's another way of putting it," I said. "But tell me another thing: how do you, a gay man living in Wyoming, avoid getting the shit beat out of you on a nightly basis?"

"Gay man?" He took an unsteady half-step back. "Baby, I ain't gay. I just like dressing like a queen!" He stormed away in a wobbly huff.

I tried to assure him I hadn't meant to offend, but I was apparently no better with guys who dressed like ladies than I was with actual ladies. Dennis of the Nine Fingers had abandoned me too. He was in the corner trying to roughly force the jukebox to play a song it evidently did not contain. But it was going on 2:00 a.m. anyway, and thoughts of the doe-eyed angler

girlfriend had me missing The Girl too much to be any more fun. Even the rowdier drunks were filtering out, waving over their shoulders as the bar staff shouted profane goodbyes. I signaled Jason. He nodded and we shuffled back to the motel, where we collapsed onto our beds.

In the morning, I awoke to a blinding light leaking in at the edges of the heavy window curtains like the sun's own corona shining whitely from behind an eclipse.

Jason sat up and threw his legs over the edge of his bed. He hunched there for a few minutes, scratching his head and sighing. Then, to my great relief, he lay down again. Later on, I thought I'd give sitting up a try. I heaved myself upright. The room spun in a generally clockwise manner, and my stomach quavered like a mold of Jell-O. Jason eyed me warily until I flopped back down too.

We didn't reach the trailhead until nearly 2:00 p.m., and even then, we were still feeling poisoned. But we made the seven-mile hike in under two hours. After we got a camp set up, Jason shook his head and laughed. About Sharla and her transparent attempts to add us to the Venn diagram of Cowboy Bar patrons who were also her exes. About the imposter TV drag queen. About Dennis vainly lambasting the jukebox to make it play "Great Balls of Fire."

"Dude, it was epic," said Jason as he chuckled and poked the fire. "I haven't been that drunk in a while. Fuckin' Pinedale."

I grinned and nodded. And there it was. We'd escaped.

The next day, we hiked up to a stream that ran in sandy flat meanders through a bulrush bog. In some places, the cutthroats in their post-spawn livery were fanned out from bank to bank. I cast a Woolly Bugger upstream and stripped it back just a bit faster than the current. Three trout darted from their lies to jump the fly. The biggest one slammed the bugger, and I managed to stick him even though he'd come from straight upstream. I steered him into the eddy behind the rock I stood on and then unhooked him and sent him down the river. Jason cast into the fray, and a cutthroat took his streamer as though it were a dry fly, before it could sink at all. He cast again and caught again. I stayed on the rock and caught nearly all the fish I could see from there. Then I moved upstream just six feet and caught a three more in fast succession.

After that, the fishing got really good.

Billowy clouds had been discreetly forming along the southern horizon that morning, but as the afternoon lengthened, they became thunderheads. Now they glowered down on the stream and pelted us briefly with fat, heavy

raindrops like a salvo of warning shots. We got the message and gathered our things to head back. Soon it was raining steadily.

As a formerly devout car camper, I still often assume that once it starts raining, it'll never stop, ever, and that it will ruin the trip and possibly the rest of the summer. But an hour later, the rain cleared off, and it warmed up again so quickly that we got muggy in our rain jackets before we could take them off. That's how it sometimes goes up there. It's as though the summer storms sometimes just don't have the heart to soak you thoroughly or ruin your whole day. They just want to remind you that rain exists and that it always eventually stops. The best thing is to just put on your jacket and keep doing what you're doing, whether that's setting up your tent or hiking or fishing. Don't fight it; it'll pass.

"Good to be back up here," Jason said as we stopped to catch a few brook trout at a lake near our campsite.

"Should we start a fire when we get back? What do you want to do?"

"Let's eat those goddamn mushrooms and go fishing."

We ate the mushrooms and went fishing. But it got windy at the lake, and the brookies weren't feeding on top. I stepped out onto a huge, flat rock that slanted into the water like a boat ramp and cast as best and far as I could in the wind, winging out the Woolly Bugger I'd been using at the stream, stripping it back and waiting for a bump. Jason fished merrily fifty yards down the shore. He caught one brook trout after another. I coaxed one onto my fly, pulled him in and let him off.

As we walked back along the shoreline and across a wildflower meadow to our fire pit, I thought I felt the mushrooms coming on. It was just as the

I was finally noticing some distance between myself and The Girl, and Jason was laughing again. *Photo by Brian L. Schiele.*

mushroom dealer had described it: "You'll get this slightly panicky feeling. You know, like your system's getting hijacked."

He was right. I don't remember exactly what I'd expected, probably that the world would transmute into a Robert Crumb ink drawing as the ghost of Richard Brautigan stepped out of the woods. He'd be dressed in a threadbare corduroy sports jacket and a floppy felt-brimmed hat—the Jacob Marley of Haight-Ashbury. Regarding me through large, amber-tinted eyeglasses and stroking his droopy mustache, he'd ask me about The Girl, who I would suddenly begin referring to as The Girl Who Travels with Me. The personified embodiment of Trout Fishing in America would likewise arrive, and the three of us would share a campfire. Brautigan would explore his preoccupation with Hollywood starlet Deanna Durbin, while Trout Fishing in America would recount how Lewis and Clark paddled up the Missouri River to Great Falls and caught half a dozen trout there, sixteen inches up to nearly two feet long.

But the mushroom dealer had told me true—a system hijack, an instant of vertigo, like catching yourself when your chair almost tips over backward. And next, if you don't panic, a subtle shift in perception. Not a shift in reality, but the way you see it.

All at once, every color took on a perplexing distinctness. At first I thought that my rods and cones had somehow swapped places and that I was seeing the colors like a solarized image or a film negative, with the blues all turned to orange and all the yellows changed to purple. That wasn't it, though. Everything stayed its own color, but their individual shades no longer bore any resemblance to each other. The green of the grass was altogether different than that of the aspen leaves, and the green of the aspens had less in common with the silvery green of the alders than yellow has with black. The spruce trees were their own particular green, too, and the new growth at the end of each bough was its own completely different hue, as though some entirely different species had been meticulously grafted into the tip of every branch. The drooping blooms of the bluebells in the wildflower meadow blazed in shades of ultraviolet like the fluorescent flames of ten thousand cookstoves, and in the flattening light the ubiquitous electric yellow of the wild buttercups shone so conspicuously I felt it'd be a simple thing to count every single one in the valley, even on the hillsides miles away.

And Brautigan was nowhere to be seen. He and Trout Fishing in America missed the entire proceedings.

It turned cool, so I knelt at the fire pit. With the deliberate motions of an astronaut repairing the exterior of a spacecraft, I lit some tinder and added

a few twigs. As the fire came to life, I was unsurprised to see turquoise and dark purple and even inky black in the flames.

Jason reappeared. I'd lost track of him, but he was suddenly across the fire pit from me, hands in his pockets and grinning.

"What's up?" I asked.

"Oh, I'm tripping," he announced.

"You are? I don't think I am yet." I stared at the chemical green and fuchsia flames. "I can't tell."

And it was true. In that moment, I doubted the effects. So I looked up from the fire pit and out at the lake, scanning for some kind of firmly remembered visual reference. Fish were dimpling the water's surface. We'd quit fishing too soon and missed the evening rise. The radiating S-waves of each rise ring glided over the water and to the shoreline and continued onto the land, passing through me and on behind me forever. I certainly couldn't recall that ever happening before. I looked out over the rest of the valley, and as the mountains glowed like distant troves of gold, I became profoundly aware of the texture of granite, the way it consists of trillions of tiny mirrored facets and how it shatters sunlight into trillions of tiny sunbeams.

Still unsure, I raised my eyes to the evening clouds shining high in the waning sunlight, and instead of discrete billowing forms, I saw their component water droplets condensing and gathering and dispersing. I was so amazed by this I fumbled around for my camera to take a photo of it. But I forgot it was a digital camera—or maybe I'd forgotten that digital cameras existed—because I tried to compose the shot by peering through the viewfinder, but the camera didn't have any viewfinder.

Jason laughed. "Dude, what're you doing?"

"The clouds. Check out the clouds."

He did. "Whoa," he said. "I see what you mean."

I finally took a picture of those clouds. I still have it. There is nothing remarkable about it at all. But if I could see tiny facets of granite on the mountains ten miles off, and if I could see individual water molecules forming cumulus clouds at twenty thousand feet, what would I see if I closed my eyes and looked inward?

Near my tent there was a broad, low bed of grass and moss. I went there and lay down on my back, and then I closed my eyes, searching for the shift.

There she was. The Girl Who Travels with Me.

With the mushroom compounds coursing through my bloodstream, I assumed I'd see a kind of reverse image of her too. Or maybe I'd see the entire relationship with some terrible new distinctness or coloration, which

would reveal something I didn't know before. But The Girl didn't change a bit. Her eyes were the same surprising blue, her hair dark and glossy, her lips red and parted over straight white teeth. I felt her soft pale hand curling into mine, and she herself curling into my arms as we lay in bed, like an ivory-skinned naiad sheltering in a fallen leaf.

But The Girl was tempestuous. The Girl was imperious. She'd break up with me on a Monday and then call the following Sunday to berate me for not begging her to take me back the previous Wednesday.

I'd answer the phone, and she'd say, "You haven't called me in almost a week."

"Babe, we're broken up," I'd answer. "You broke up with me."

"Exactly," she'd yell. "And I've been waiting this whole time for you to do something about it!"

She was an exquisite crystal decanter brimming with the most volatile nitroglycerin, and all I wanted was to drink her up.

The sun went down, and a deeper chill settled in. I got up off the ground and broke a few branches to stoke the fire. Deep, heavy snow in the mountains the previous winter had left behind lots of pushed-over saplings and broken-off branches that were still very green by the time we got there that summer. We'd gathered up armfuls of it to burn, but it smoked copiously before catching fire and then hissed and bubbled, bleeding gouts of sap that ran down into the coals like molten glass. Some of the spruce boughs still had green needles, which when lit crackled like bricks of Chinese firecrackers.

But the merry blaze fended back the cold. We stood close to the fire and held out our hands to embrace the warmth, but then a pine knot would detonate and shoot hot sparks like machinegun tracer rounds and we'd flinch away, slapping at our clothes. Eventually, the logs burned through and crumbled, forming a heap of incandescent embers, wavy beneath the warping air from its own intense heat.

"Dude, this is one epic bed of coals," said Jason. Then he stared as though lulled into a trance.

I didn't want the fire to die down, so I dumped on more of the green branches. They smoked awhile on the coal bed and then ignited like oil-soaked rags, flaring so brightly we turned away our faces and stepped back. My nylon camping pants and down jacket seemed only seconds from melting to my skin.

The stars came out, and the mushroom's effects began to recede, like a scrim pulled back from a stage. I'd used up all the firewood, so we had a few slugs of the Jack or the Jerry and then climbed into our tents.

I anticipated a psychotropic dream vision in the night following the mushroom trip, but that failed to materialize too. Inside my tiny tent, I didn't dream or stir until sometime very early the next morning, when I woke up needing to pee. I lay there for a while in the darkness until my bladder ached like a wound, and only then did I crawl out of my tent. In my stocking feet, I winced and limped over the rocky ground to a low stand of spruce trees, where I pulled down my thermals.

Everything glimmered softly in the starlight. The mountains were distant hulks of negative space obstructing the stars, the lake a yawning, starry passage to the sky's mirror image. I wasn't sure what time it was, but dawn seemed seriously overdue. I began to shiver, but my head felt very clear. I didn't need a phantasmic Richard Brautigan or Trout Fishing in America to understand that I hadn't escaped from The Girl at all.

How happy she would be if she knew. How badly she'd want it this way. Even if she really did want nothing more to do with me, which I doubted sincerely, I knew she'd be very satisfied to discover that despite the booze and the 'shrooms and the long hike, I hadn't gotten away from her.

And it could have been the 'shrooms talking, or the booze, but something told me that she already knew I was thinking of her and had been almost the entire time. This made me smile a little, despite how it galled me, because there in the monochrome of night was the vision I'd watched for. And in later days I have often wondered if it was real or if it was perhaps only another part of the mushroom trip. Had I gone out of my tent to pee or had I actually found the way out of my head at last? The vision was not polyprismatic, but it was vivid and prophetic. It was a view of how life might be without The Girl—cold, colorless and without dawn.

The reality was that I hadn't gone away to escape her in the first place. I'd gone looking for her, and I found her in the bluster of each thunderstorm and the withering smolder of campfire coals. Yes, she was fiery. Yes, she was stormy. Since when was that a character flaw? So what if she burned hotly? She was also passionate and sincere and loyal to a fault. What did I want instead? Her opposite? Someone dull? Someone dim?

My teeth began to chatter, and I thought of the coals in the fire pit, how they were buried by now beneath a blanket of white ash and still hot all these hours later, how they'd probably still be warm when we wanted a fire the next day. But fire doesn't just appear from nothing. It needs fuel, oxygen, ignition. Surely I was responsible for half of the dozens of fights I'd had with The Girl, for the times our relationship had been engulfed in flames.

Photo by Chadd VanZanten.

Like when I'd correct her grammar in the middle of an argument. "You don't care about me," she'd bawl. "You just lay there on the couch while I sit here and cry."

"Baby," I'd tell her, "it's *lie*, not *lay*."

She'd quit the sobbing, lift her eyebrows, and snap, "Excuse me?"

"You mean *lie* on the couch. *Lay* takes an object. It's transitive."

How many armfuls of green, sappy wood had I stacked on her seething coals? As I stood there with my underwear pulled down, I saw the sky off in the east beginning to color, too faintly yet to name its shade but distinct enough to know it was dawn.

I called The Girl when I got back into town.

"So," she said, her voice testy, "you miss me."

"I think what I said is that I've been thinking of you."

"Oh, so you don't miss me. That's what you called to tell me?"

The Girl made me work harder than necessary for the reconciliation. She called for reparations. It took several weeks. I bridled at first, but then I remembered the thunderstorms and how they always receded eventually. And I remembered the fire pit and the way I embraced its blistering heat but also how it launched its embers like bullets so that I had to stand back at times and squint when it was too much. Let her storm, I thought. And let her flare up and blast until her blood turns to molten glass. At least we would always stay warm.

PATH OF TOTALITY

I was beginning to think that Klaus had forgotten how to fly-fish.

It had been a while since he'd done any serious casting. I knew that. But here we'd just arrived in one of the most remote Wind Rivers drainages that I knew how to get to on foot, where the unhassled trout are polite enough practically to jump into your net unbidden, and there was the son I'd taught to fly-fish, fouling his line and missing strikes.

Klaus first picked up a fly rod when he was ten or eleven. Back then, he had a knack for loops, range-finding and mending. One day, while fishing Cinnamon Creek on the south end of Cache Valley, we came upon a couple brown trout, maybe two pounds apiece, lurking in the slower flow along the bank side of a riffle that ran underneath some low-hanging tree limbs. Definitely two of the larger fish we'd seen that day.

Klaus asked, "How can I get them? Without hitting the tree, I mean?"

"There's this thing called a slingshot cast," I told him.

"How do you do it?"

"I can show you, but I'm not that good at it."

Klaus watched as I made a couple downstream slingshot casts to demonstrate.

"Like that, see," I said. "Only, you know, do it better."

Despite the subpar instruction, Klaus seemed to comprehend the basic idea. He knelt in the river like an archer, pulled back on his leader to load the rod tip and aimed for a few seconds at the spot where the trout hovered unwitting in the slack current. Then he let go. The loop shot out tight and low, turning over and laying the fly right up under the

branches on the seam between the faster and slower water. One of the browns turned to the fly and ate it, and Klaus set the hook like he'd been slingshot casting to that very spot all summer. The only way I would have been more surprised is if he had instead slogged ahead to pluck the trout from the water with his hand.

The brown trout was understandably perplexed by all of this, too, but Klaus played it very cool, as though there'd been little doubt about the outcome. He worked the fish to his net in a conspicuously nonchalant fashion, made a "not bad" face as he held up the fish for me to see and then let it swim away. For the next hour, he threw nothing but slingshot casts, whether it was called for or not.

Klaus's casting and his ability to read the water got even better when we started backpacking into the Winds. We both improved. When you remove so much of the uncertainty about where the fish are and whether they'll strike, it's easier to advance yourself in the art.

But now, there on the bank of a lake where fish were steadily rising, it looked to me like maybe Klaus had returned to the Winds a day or so after forgetting everything he'd known before. I waited as he untangled a bird's nest of line and leader he'd created after letting the breeze get the better of his cast.

We'd arrived at the lake only a few hours before. After we'd gotten our camp set up, we'd come down to the shore to fish a little while it was still light. A low grassy area abutted the lake's inlet, and I knew from a previous visit that there were good fish there, so I pointed out a spot where Klaus could cast onto the flowing water. Then I sat down and waited for him to catch a fish.

"Just get it onto that foam line," I said. "That's where they'll be."

Klaus made a few short casts and got a take, but he was fiddling with his slack and didn't see it until it was too late.

"That's all right," I said, waving at him to continue. "Try getting it a little farther out. Cast to the foam. And easy-does-it when you set the hook."

He repositioned himself slightly, checked his backcast and cast short again. "Dang it," he muttered. "Not used to this rod."

"No big deal. Soon as you get it out there, you'll get a nice fish. You can see 'em out there, right?"

"No," he said, shaking a twist out of his line. "Well, I see one. Where are they?"

"Out under the dots of foam." I pointed. "There's a riser. And there's one right behind him. Right there. See him?"

"Yeah. I'm just trying to—" The fly struck the rod with a nasty *clack* as he made another cast. His loop collapsed and drifted down onto his neck and shoulders. "Dang it. Hang on."

A steady breeze had been blowing up the valley, but it began to gust harder and it came straight across the line of Klaus's cast. He seemed helpless to compensate or power through it.

As he labored through cast after fruitless cast, I began to realize that those trips we'd taken, back when Klaus had a squeaky voice and gorgeous fly loop, were now almost completely shrouded in what is usually referred to as "The Past." Not just "a few years back" and not even the more vague "some time ago," but The Actual Past. Yes, it'd been a while since he'd done any serious casting. I knew that. But I'd been looking back with that peculiar inability of a parent to acknowledge that their children will ever proceed to adulthood. I had somehow missed the fact that Klaus was now heading for his mid-twenties, and I grudgingly admitted that it might have been more than a few years since we fished together.

And although he and I apparently got along well enough to spend an entire week together by ourselves in the mountains without the aid of the Internet or smartphones or even other people, there was an issue that sat awkwardly and inconveniently between us.

In what I figured was probably the inverse of what many fathers and sons experienced, I'd quit Mormonism, our lifelong faith, while Klaus had remained devout. He was a believer; I was at best an agnostic with completely unreasonable standards of proof. A few years earlier, I'd given Klaus my reasons for abandoning god, trying hard not to unconvert him in the process, and Klaus listened with a sort of skittish sincerity, making no attempt to reconvert me. But since then, we'd rarely spoken about it. I suspected it was one of the reasons we didn't fish together much anymore, and I often wondered if Klaus had grown skeptical of me. I'd taught him about Mormonism and then unceremoniously forsaken it. Had I subverted everything I'd ever tried to teach him?

He was not enjoying himself there on the lakeshore, that much was clear, but he didn't seem interested in advice, either.

"So, when was the last time you actually fished?" I asked.

"I dunno." He shrugged and picked at a wind knot in his flyline. "I guess I was probably fifteen."

Seven years. That's when it occurred to me that I was probably making things worse.

"Huh," I said. "That long. All right. Well. You keep at it. I'm gonna go start a fire."

"Okay." He sounded relieved.

I consoled myself with the reminder that we hadn't hiked into the Wind Rivers that year solely to fish—we made the trip ostensibly to observe the full solar eclipse, which in August 2017 crossed the full breadth of the continental United States. Astronomers had announced that just about everyone in North America would be able to see it, at least partially. Throughout much of the lower forty-eight states, depending on latitude, it would look like the sliver of a solar fingernail. Up in Canada and down in Mexico, it might look more like a white cookie with a bite taken out.

And even Alaskans, Hawaiians and skygazers in central Brazil would be able to witness it, but the astronomers had drawn a special gray band seventy miles wide across the United States only, beginning at the Pacific coast of Oregon and sloping gently downward to the Atlantic coast of South Carolina. This, they said, was where the shadow would fall as the moon passed between Earth and the sun. They called it the "path of totality." Within it, they said, you'd see what was termed "100% obscuration," visible with the unaided and unshaded eye, with the sun's dazzling corona flaring radiantly from behind the cosmically black disc of the moon.

Then, within the gray path, running straight down its center, they'd drawn another line, a thin red one. Along this line you could stand on the surface of the turning Earth and pass beneath the moon's shadow at its widest point, thus observing the eclipse for the longest possible moment.

At the time, people made this out to be a big deal. Sure, there are two or three full solar eclipses every year, sometimes more, but the tiny shadow cast by the moon falls on less than 1 percent of Earth's surface during any given solar eclipse—and often it's in places where few people are willing or able to go. This would be the first full solar eclipse witnessed in the contiguous United States since 1979, and the first one observable exclusively from within the United States since 1776—shortly after the United States were founded and long before there were fifty of them.

Indeed, friends of mine later described the occasion as "transcendent" and "life changing," although I suspect some of those declarations may have been subconscious attempts to justify the unexpectedly arduous efforts required to reach the path of totality, such as hours spent parked on congested state highways or paying for rooms at hotels that raised their rates obscenely and without scruple. I heard that in Driggs, Idaho, just a few miles off the red center line, people were renting out their guest bedrooms for $1,200 per night.

I didn't book the trip hoping for glamor or epiphany, or even to scratch something off a list of things to do before dying. It just so happened that one

of my favorite places to visit in the Wind Rivers was situated eight miles from the red center line of the totality path, and so I planned my 2017 trip for the week of August 21 instead of early July, as was the more typical schedule. Klaus said he'd join me, just like old times, and so it seemed more like a better-than-average excuse to reconnect with him.

But to say that I hadn't come *solely* to fish really meant that I was there *expressly* to fish for the entire six days of the trip except for the two or three hours it would take to observe the eclipse. And so I worried that if Klaus couldn't straighten out his cast he might end up piercing his own face or putting out an eye—possibly mine.

And it could be even worse. If this supposed big deal turned out to be a small one, Klaus might not enjoy himself at all, and that's one of the most bitter pills a parent ever has to swallow.

On the morning of the eclipse, there was no wind and only a few clouds snagged up in the haze that settled over the western horizon. It was as though the place itself had gotten caught up in all of the excitement and hadn't bothered to arrange for any weather. I ate some breakfast while Klaus set up his camera gear: tripods, special lenses, filters.

It was a little after 9:00 a.m. when we noticed that the light had shifted. "See that?" Klaus said, studying his own hands, turning them over in the hampered light. "It's like someone's messing with the saturation settings in Photoshop." He was right. There was suddenly too much indigo in the air. The edges of our shadows had softened and blurred. I kept wanting to remove my eyeglasses to see if they'd been smudged.

We got out our sun-viewing glasses. They were made with cardstock frames, like old-time 3D movie glasses. The lenses were Mylar foil. We put them on and tilted our faces to the sun.

"Yeah," said Klaus, pointing. "It's starting. Look. You can see a notch." He was shooting photos every minute or so.

For the better part of an hour, the darkness gathered. The moon's shadow encroached slowly from the lower right, moving up and westward. The songbirds fell silent, and even the ravens paused their morning bitch session. The red mercury in my zipper-fob thermometer said the temperature fell from sixty-five degrees Fahrenheit to a little below fifty. Every dapple of sunlight beneath the trees had been recast into the shape of the obstructed sun, so that the ground was sprent with a million little golden crescents.

Klaus shot more photos. I squinted over the top of the paper-and-foil glasses. As the moon rose up, traversing left, the shrinking face of the sun seemed to flare more brightly, as if in last-minute protest. Soon only the

"wedding ring" effect remained, a thin rim of light encircling the moon, topped by the blinding thermonuclear diamond.

And then it was night. We removed our glasses. The moon stood in the air like a portal to some place of perfect emptiness beyond, while the unconditional whiteness of the sun's corona seethed coldly at its edges. It was perhaps the blackest and whitest thing I would ever see within a single gaze. The horizon in all directions was cast in the colors of sunset. Venus and some of the brighter stars shone weakly in the sapphire sky.

As the moon glided onward, time flowed backward, as though the universe had reached some unsatisfactory middle-place in its existence and was now reversing to its beginning. The light returned, transitioning through shades of indigo to deep blue and back to golden again. The shadows reformed, hazy at first, sharpening with time.

When the birds started up again, we knew it was over. We watched the last of the moon's occlusion by holding the eclipse shades up to our eyes like opera glasses. Then we looked at each other, each apparently waiting for the other to furnish some closing remark.

"Huh," was all I could manage.

I'm still not sure how big of a deal it really was. There was something to it. I should mention that the event was not without a certain geopolitical ominousness, given the situation in the White House at the time, so what I felt may have been a very real sense of relief that the eclipse passed without apparently triggering some new nationwide cataclysm. But more likely it was the simple and actual majesty of these two unimaginably massive and distinct celestial objects interacting with such pageantry. To be in the place where it could be seen. And there was a sense of sudden kinship with the primitive humans who upon seeing the spectacle took it for a portent of evil or fortune, or as unshakable evidence for the existence of some deity. Because even though I knew why it had happened, what it meant has been harder to explain. For now it serves as a kind of cosmic marker of exactly where I stood at the instant of totality, aligned with the moon, sun and Earth, trying harder to align with the people around me. Gazing simultaneously into perfect light and perfect darkness, reason and belief, closeness and distance.

For now, I'll say that I was pleased to have shared whatever it was and whatever it may become with the son I hadn't tripped with in a while, the son who'd forgotten how to fish.

The eclipse fell on the middle day of our trip, so we still had lots time left for fishing. Klaus straightened out his cast enough to hook many handsome fish, and he did it without much advice from me. He figured

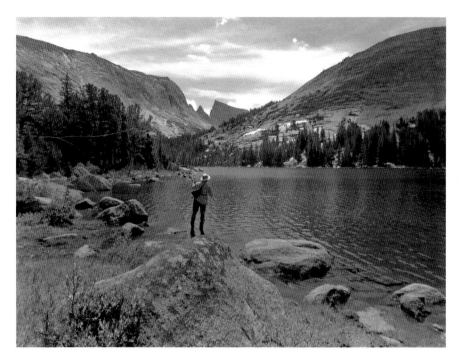

Photo by Chadd VanZanten.

it out himself—just in time to go home again. On the evening before we packed up to hike out, he caught several good-sized cutthroats at the grassy spot by the lake inlet. I like to think at least one or two of these were fish he'd missed that first day.

But in the hour or two immediately following the eclipse, we didn't go back to fishing right away. Instead, we stood there in our camp where night had so abruptly fallen and then lifted just as suddenly. When you're lucky enough to see total obscuration, you apparently linger awhile. As the morning warmed to afternoon, Klaus began to put away his camera gear. I washed and stowed my cookpot and then made ready for a hike somewhere along the path of totality. We went fishing, but throughout the day and the rest of the week and since, we paused now and then to recall some peculiar detail of the totality and to wonder aloud what it meant.

THE ARTIFACT

n *The Habit of Rivers*, Ted Leeson confessed that he prefers fly-fishing to all other forms of fishing—and trout to all other species of fish. I feel the same way.

Leeson ranks trout over suckers, catfish, whitefish and grayling, and he even places trout above steelhead and salmon. He said, "I prefer to fish trout, in part, because they take artificial flies readily…and I like to fly fish, in part, because it is the way you catch trout."

Again, I agree.

Within the trout family, Leeson outlined his sub-hierarchy of choiceness, and unsurprisingly, brown trout are at the top of that list. Rainbows come next, and after them are the brook trout. Cutthroats are at the bottom of the list.

Oncorhynchus clarkii is least desired. Here is where Leeson and I part ways.

Trout are Leeson's first choice among all fish, which means the cutthroat at least are the "worst of the best," but really? Last? I understand Leeson's penchant for brown trout. They're tough, canny and under the right circumstances brawny, with the baleful comportment of the wolf or monitor lizard. They are the true trout, and even their narrative is bold and dominant—everybody knows that the legendary unhookable old lunker allegedly lurking under a sunken log in the local swimming hole is a Loch Lomond brown. And the spread of *Salmo trutta* from Europe and Asia to practically the entire rest of the planet seems less anthropogenic and more like an act of will by the trout themselves.

But cutts at the bottom?

In the spirit of angling comradeship and in deference to Leeson's profound talent as a writer, I'll overlook this slight. Cutthroats are at the top of my list, but Leeson himself pointed out that each angler's most-wanted list is not only subjective but also arbitrary, since our choices are usually just reflections of our experience and backgrounds.

This is certainly true in my case—I value cutthroat trout over the others because when I took up fly-fishing, I happened to live in the Bear River watershed of northern Utah and southern Idaho, where cutthroats are indigenous, self-sustaining and almost genetically unchanged from their evolutionary origin. In the Bear River, cutthroats are not just natives, they're aboriginals.

If you find it petty to apply a DNA test before bestowing approval upon a captured fish, I won't argue with you. It seems discriminatory and even fascistic. However, it's not a matter of intrinsic genetic superiority. It's more about connection. Catching one fish, any fish, feeling the throb of it in the flex of a fishing rod, is a way for anglers to connect with all fish. In the same

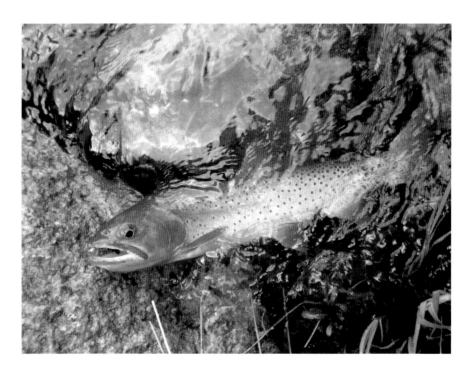

Everywhere in the West, cutthroat subspecies are battered and squeezed. *Photo by Chadd VanZanten.*

manner, capturing the native fish of a specific river is a way to connect with its entire biome and natural history. A flyline that connects you to a Bear River cutthroat also connects you to the Great Basin's earliest epochs. They're like potsherds or arrowheads but vastly older. A Bear River cutthroat trout is an artifact fifty times older than Stonehenge.

The Bear River cutthroat trout narrative is likewise compelling. In prehistory, these cutts roamed the mighty fluvial waterworks of the Bear River, growing to their full measure and choking the tributaries with their spawning runs; the Shoshones had only to walk up to the banks and take what fish they needed. Then came white settlers in the 1850s, and their overharvesting drove the Bear River cutts to the edge of extirpation. The cutthroats hung on, but their numbers were greatly reduced. In the late 1800s and early 1900s came dams and irrigation, grazing, clearcutting, nonnative species introductions and continued overharvesting. Somehow, the cutts held on again.

Other cutthroat strains in other drainages have suffered similar indignity. Everywhere in the West, cutthroat subspecies are battered and squeezed. Lahontan cutthroats, once considered extinct, were rediscovered only by accident and now inhabit a miniscule fraction of their native range. The greenback cutthroat, the aboriginal trout of the Platte River, is holed up in a single stream in Colorado. The yellowfin and Alvord strains were not even that fortunate and are gone now for good, mostly due to hybridization with rainbow trout.

The outlook for cutthroat trout is slightly better in the Bear River, which originates at the northern tip of the High Uintah in eastern Utah. From there it flows north through extreme western Wyoming and into the southeastern corner of Idaho. Then it hooks south like a shepherd's crook and winds back into Utah at its northernmost border before draining finally into the Great Salt Lake less than one hundred miles from its own headwaters. The Bear may once have thundered along at ten thousand cubic feet per second, fed by a fertile network of tributaries and spring inputs. It's the largest river in North America that withholds its flow from any ocean, and it contributes more water to the Great Salt Lake than all other inputs combined. But today the Bear is dammed a dozen times, encroached by agriculture and drastically diverted; many of its tributaries are de-watered by annual irrigation claims.

The Bear River is still an impressive system, but it's a shadow of its former greatness. The cutthroat trout population there subsists as a remainder of a remainder, the ghost of a ghost.

And that is the allure. That's the hook in their story.

Bear River cutthroat trout are not rediscovered, reintroduced or genetically reassembled. They are real. Their antecedents are the primordial salmonids that rose up from the Pacific Ocean and probed westward into the Snake and Columbia drainages over the course of perhaps 5 million years. Cutthroat trout migrated into the Rockies and the Great Basin and then over the Continental Divide. Think about that. Slowly they evolved, never speciating completely but changing enough so that they are now sorted by fish biologists into many subspecies.

The glaciers and Lake Bonneville receded, but the cutthroats stayed, flourishing in the most arid country on the continent that can still harbor trout. And so, despite its fallen condition, the Bear River cutthroat has never been entirely broken. They've maintained an uninterrupted occupancy of their natal drainage. They are the forest spirits of some ancient cycle of legends: elusive, rarely glimpsed, displaced by modernity.

When you bring a sixteen-inch cutthroat up from the dark blue of a bend in a freestone tributary of the Bear River, you sense their incredible potential. If only the Bear could be unleashed again, if only it could be given back to the cutthroats, what a spectacle that would be. Every Bear River fly angler dreams of this.

When I hike into the Wind Rivers, I pack up my reverence for the cutthroat and take it with me. The cutthroats there are not the Bear River strain, of course. Before the fish-stocking heyday of the late 1800s and early 1900s, only a small fraction of the streams and lakes in the Wind Rivers contained any trout at all, and they were all the Colorado River strain. These were displaced or hybridized in the 1930s by the 2.5 million nonnative trout said to have been stocked by Finis Mitchell, an unemployed railroad worker who ran a fishing camp and guiding service at Mud Lake in the Big Sandy Openings.

Nowadays, the best one can say is that the lakes and streams of the Wind Rivers do indeed contain cutthroat trout. That's all. Unmixing their genetic make-up would be like separating a bowl of chili into its original ingredients.

In other words, Wind Rivers cutthroats are mongrels. But they are hefty mongrels, and there are a lot of them, although it's not easy to find any two that look very much alike. Some of them are patterned in closely spaced specks of pepper. Others look like they're splattered by a few drops of spilled ink. Some are deep bronze and reddish; others are bright and silvery. They're painted in every combination of these and other variations.

They're also naturalized and self-sustaining, and catching them is excessively satisfying. Nothing is lost. Nothing is diminished by their

dubious heritage. And their appeal has less to do with their size and numbers than you might think. It's more about what the fish have become. The Wind Rivers is so remote and left-alone, the cutts there have reverted to behaviors they must have possessed before the advent of humans and the artificial fly. Unlike the Bear River cutthroat, which are in many ways strangers to their own waters, the Wind Rivers cutthroats, with their multivaried morphology, have gone native in waterways where there were no cutthroats before, devolving into primitive versions of themselves, growing wild and remaining unjaded by the tireless bother of anglers. They are the cutthroats that we cutthroat anglers wish cutthroats to be.

The fearlessness of unpressured cutthroat in a backcountry stream may surprise you at first. They're not the strongest or meanest of the trout; they're almost the opposite, and so you assume they'll be shy and skittish. Instead, in the backcountry, the cutthroat move to a dry fly languidly, like a beautiful woman knowingly undressing before a window. Instead of a sly or lightning-fast strike, you see a backcountry cutthroat's every motion, from the sideways shift across the drift and the slow tail-wag of the rise to the offhanded take and the petulant head-jerk that often follows.

It helps that wild cutthroat are found in transparent water. This makes them easy to see, even from long distances. And because seeing a trout so clearly as it eats a dry fly is for many fly anglers the point of casting a dry in the first place, setting the hook on a wilderness cuttie may begin to seem unnecessary. It may also require some getting used to—there's a delay, a sleepiness, to the backcountry cutthroat dry-fly hookset, especially if the fish is large. Lift the rod tip assertively, but act like you're maybe not very concerned about how it turns out. Fly casual.

If the Wind Rivers cutthroat was scientifically noteworthy or in need of preservation, fishing regulations (or your own ethical code) might prohibit you from harvesting them. But if you're inclined to keep and eat fish, doing so in the Winds will not make a dent in their self-propagating numbers, nor will it interfere with any study efforts. On my last trip to the Winds, my son Klaus and I caught and killed two cutthroats, each about fifteen inches long. We'd brought a small bag of masa for making corn tortillas. Klaus added a little water and patted the masa dough flat in his hands. We cooked the tortillas on a hot rock and spread the cutts over the coals of our campfire. Then we squirted the fish with freshly quartered limes, wrapped it in the tortillas and ate cutthroat tacos, absorbing and re-assembling their genetic material to carry with us yet farther abroad.

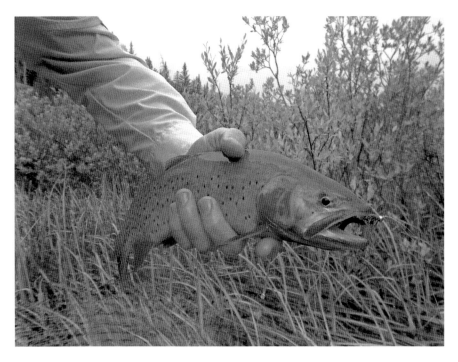

Photo by Chadd VanZanten.

These backcountry mongrels were planted too hastily for the philosophy of conservation or the science of ecology to catch up, and so although they lack the continuous habitation of a native strain, they are nevertheless a remarkable wild population, perhaps the seed of a new aboriginal species that future fish biologists will puzzle over after our civilization has been gone for a few hundred millennia.

Until then, the Wind Rivers cutts provide such a vivid picture of what their shooed-away and genetically blurred-out ancestors were once like. They again furnish that strong sense of connection, not just to a fish species but to a remote place and time. They are the artifact of cutthroats as they were and what we dream they might be again. Not an artifact excavated from underground, but one instead found under clear water—and not an artifact made of stone, but alive.

THE WAY YOU KNOW

Cutthroat trout
swims up
from the stream bed
and the way you know
it's a cutthroat
is the red on his throat.

Red, not unlike
the color of the lips
of the lover
who waits, the girl
who makes you want
to cut the trip short.

ABOUT THE AUTHOR AND THE PHOTOGRAPHERS

CHADD VANZANTEN is an outdoor writer and environmental editor. He is co-author of *On Fly-Fishing the Northern Rockies: Essays and Dubious Advice* and many essays on fly-fishing and backpacking. Chadd was named Writer of the Year in 2015 by the League of Utah Writers. When he is not fishing, he is writing. The opposite is also true.

KLAUS VANZANTEN is a photographer, fly angler, filmmaker and journalism student based in northern Utah. He works as manager of video production for Utah State University Student Media. This is his first book.

BRIAN L. SCHIELE is a Harley rider, tenkara fly angler and U.S. Army veteran. He likes long walks on the beach and even longer rides on his Harley with his badass wife, who also rides. Brian is a "Holga Master" photographer whose work has appeared in *This Is Fly*, *Kype* and the *Flyfish Journal*, along with his own book of photography: *Trout Dreams*. However, Brian is most proud of his work as a dad.

Holga Photography

The photography of Brian Schiele featured in this book was shot with Holga equipment—primitive, consumer-grade "toy cameras" that originated in China in the early 1980s. Because Holga cameras are cheaply made, constructed almost entirely of plastic and mass-produced with manufacturing standards that one might call "relaxed," the resulting photographs often exhibit light leaks, camera lens artifacts and other flaws that result in an evocative, nostalgic style. Holga photography is an example of the wabi-sabi aesthetic, which celebrates the imperfect, incomplete and ephemeral.